HOW TO DRAW

DIGITAL MANGA AND ANIME

PROFESSIONAL TECHNIQUES FOR CREATING DIGITAL MANGA AND ANIME, WITH 35 EXERCISES SHOWN IN 400 STEP-BY-STEP ILLUSTRATIONS AND PHOTOGRAPHS

TIM SEELIG, YISHAN LI AND RIK NICOL Consultant editor: ANDREW JAMES

This edition is published by Southwater, an imprint of Anness Publishing Ltd, Blaby Road, Wigston, Leicestershire LE18 4SE; info@anness.com

www.southwaterbooks.com; www.annesspublishing.com

Anness Publishing has a new picture agency outlet for images for publishing, promotions or advertising.

Please visit our website www.practicalpictures.com for more information.

Designed and produced for Anness Publishing Limited by Ivy Contract

Publisher: Joanna Lorenz
Project Editors: Hazel Songhurst, Sarah Doughty, Susie Behar and Dan Hurst
Designer: Glyn Bridgewater
Jacket designer: Lisa Tai
Art Director: Lisa McCormick
Artists and Contributors: Yishan Studio, Rik Nicol, Wing Yun Man, Jacqueline Kwong and Tim Pilcher
Production Controller: Mai-Ling Collyer

© Anness Publishing Limited 2012

All rights reserved. No part of this publication may be reproduced, stored in a retrieval system, or transmitted in any way or by any means, electronic, mechanical, photocopying, recording or otherwise, without the prior written permission of the copyright holder.

Previously published as part of a larger volume, The Practical Encyclopedia of Manga

PUBLISHER'S NOTE

Although the advice and information in this book are believed to be accurate and true at the time of going to press, neither the authors nor the publisher can accept any legal responsibility or liability for any errors or omissions that may have been made nor for any inaccuracies nor for any loss, harm or injury that comes about from following instructions or advice in this book.

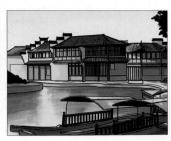

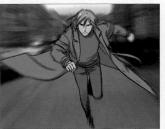

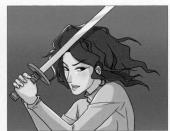

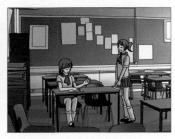

Contents

Chapter 1: Digital manga	4	Chapter 3: Improvements	
Tools of the digital trade	6	and beyond	56
Introduction to Adobe Photoshop	8	Customizing colour palettes	58
The paint tools	12	Creating motion	60
Other useful tools	16	Creating a metallic look	62
Photoshop layers	18	Creating reflections	64
Scanning and retouching an image	20	Converting a photo	66
Digital inking	22	Creating lighting	68
Toning techniques	24	Combining software	70
Speedlines and focus lines	28	Digital shojo project	72
Style of lettering	30	Digital shonen project	74
SFX lettering	32	Digital kodomo project	76
Using filters	34	Digital seinen project	78
Inked background project	36		
Robot in space project	38	Chapter 4: Anime	80
Fight scene project	40	The history of anime	82
		Software	84
Chapter 2:		Pre-production	86
Digital colouring	42	Animation	90
Colouring basics	44	Cute dancer project	92
Colouring techniques	46	Walk-cycle project	94
Colouring a page	52		
Night image project	54	Index and acknowledgments	96

Tools of the digital trade

Most modern manga artists use computers to help them create artwork, to greater or lesser extents. Some draw and tone everything on paper, using the computer to clean up the pages and publish them online. Others draw directly into the computer, using a mouse or stylus and graphics tablet, and publish the results as a traditional paper-based graphic novel.

Digital methods can be used whenever and wherever the artist finds them convenient and comfortable. It is possible to work with just pen and paper, but in this digital era, it is hard to avoid computers completely. Once a few simple techniques are mastered, they usually prove faster and more convenient than traditional methods.

Hardware - PC or Mac?

The most important and expensive piece of equipment a digital manga artist will have to invest in will be a computer and monitor. However, provided it has a large enough memory, and fast enough processor, a good computer should last about 4–5 years before it needs

replacing. Most computers have dual processor chips of at least 500MHz, which is powerful enough to deliver 7 billion calculations per second. The monitor should be a high-definition screen with a viewing area of at least 15 inches. Most monitors are flat-screen

LCD display panels with 1600 x 1024 resolution. A storage device, such as an external hard drive, is extremely handy as well, as it will save large files that would slow down the computer, and will backup important documents, should the main hard drive break down.

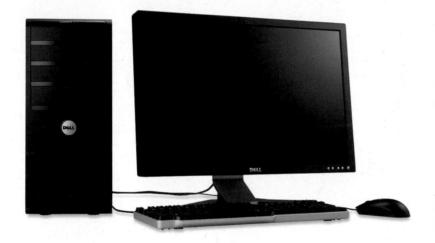

Computer A

A home computer is no longer a rare device in households; most families have at least one to store music and photos. watch movies and surf the Internet on. But not all home computers are suitable for drawing manga. Some will be too slow to run graphics packages, such as Photoshop or Corel Painter. In order to make sure the computer is powerful enough, check the software's minimum system requirements, normally printed on the box. The computer must match these. Of course, this is only the minimum requirement for dealing with relatively small pictures. Working with larger, high-resolution files requires a more powerful machine. A good starting point is 4GB of RAM memory and a dual-core 2.4GHz processor.

Monitor A

It is important that the monitor displays images correctly. This is vital for colour work, and in order to ensure precise image quality the monitor needs to be calibrated with professional software or devices, such as ColorEyes Display Pro. If the monitor is not calibrated correctly then the colour of images when they are printed on pages may not match exactly what is on the screen.

Tip: When drawing with a computer, most technical choices are made with a mouse or stylus pen. However, it is important to use the keyboard for shortcuts, which save significant time and effort. A smaller keyboard is helpful if used alongside a graphics tablet.

Apple Mac versus PC

Many manga artists tend to work on an Apple Macintosh, rather than a standard PC. The reason for this is that, until recently, the best painting and creative software was only available on the Mac. The Mac's operating system is more intuitive and better suited to how creative people think and work. Also, Macs were the preferred computer of publishers and printers, and traditionally preparing for print would have been done on a Mac. However, PCs now have all the same software available as the Mac, and the latest operating systems (Mac OSX and Windows Vista) 'talk' to each other without any major technical issues. The choice of one system over another is now more of a personal preference.

Printer >

Printing out work at home requires a good printer.
There are two types of printer to choose from: inkjet or laser. Inkjet printers are initially cheaper and therefore more popular for home users, although ink runs out quickly and replacement cartridges can

be expensive. However, as long as photographic paper is used to print on, the quality of modern inkjet printers is quite sufficient. Laser printers, especially colour ones, are initially expensive by comparison, but the advantages are higher-quality pages, lower running costs and a water-resistant printed picture.

Scanner ▼

If a drawing on paper requires more processing, or colouring, on a computer, a scanner will be needed to import the image. All-in-one A4 scanner/copier/printers can be bought quite cheaply and save a lot of desk space.

Mouse >

An optical cordless mouse is the best option for digital illustration, as they are more precise than a traditional ball-based mouse and won't clog or jam. Remember to change their batteries regularly.

Graphics tablet ▶

A graphics tablet is a far better choice for digital illustration than a mouse. Tablets are usually small boards that plug into the computer via a USB lead. Users draw on the pressure-sensitive board with a stylus, creating an image on screen instead of on paper. But quality isn't cheap: some graphics tablets are too simple for serious graphics work, so choose carefully and test your chosen model in-store if at all possible.

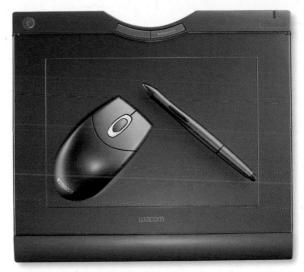

Conventional versus digital imagery

Hand-drawn A

This traditional watercolour painting shows the paper texture beneath the washes. With a little practice this effect can be recreated digitally.

Corel Painter

Different colour schemes can be tested and blended on the same line art, allowing you to experiment with variations until you are content.

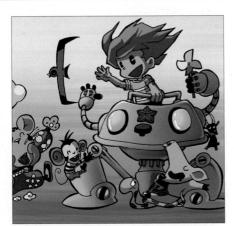

Photoshop A

The advantages of digital art include the easy mixing of techniques. Here, a graduated background contrasts with figures in a crisp animation style.

Introduction to Adobe Photoshop

Photoshop is one of the most comprehensive and powerful image-processing software packages available, and it is popular with home users and art professionals alike. This makes it the perfect program for manga artists to use.

Photoshop comes in many different versions. For the beginner, investing in the fully functional latest version can be expensive. There is a cheaper, reduced version called Photoshop Elements which is sufficient for a manga novice.

While Photoshop can appear complicated and seem nerve-racking at first, it isn't necessary to learn everything in advance to be able to use it productively. Here is a guide to the basics that will get you started on the more common drawing and painting tools and techniques. Knowledge builds with increased usage and simply playing around with different buttons can reveal exciting new art effects. The key is to get involved and to experiment.

Getting started

Depending on the computer's available memory and processor, Photoshop may take a while to open, as it is a large program. When first opening Photoshop, it will default to showing the Menu and Options bars running along the top of the screen, just like other applications. To the left of the screen is a vertical toolbox and to the right, the four palette groups: Navigator. Info and Histogram; Color, Swatches and Styles; History, Actions; and Lavers. Channels and Paths. These are the key tools and components in Photoshop required to make digital manga artwork or any other artwork you choose to create. Without mastering these it will be impossible to work in the application successfully.

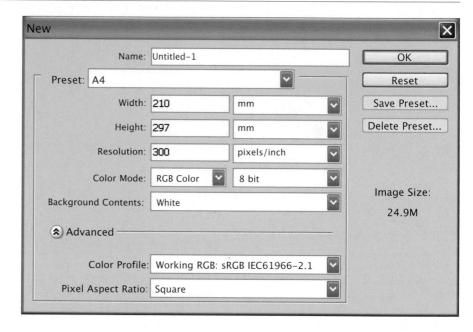

Tip: Resolution refers to the number of dots of ink per inch (for print) or pixels per inch (on screen). The higher the resolution, the better the quality. Most print images are 300 dpi, while online images tend to be 72 dpi. Print-quality comics are most often coloured at 600 dpi and printed at 300 dpi. Always scan and colour your imagery at a larger size than your final page to avoid unsightly pixellation or blurring.

The Title Bar ▼

This includes the current filename (in this example Untitled-1) and current zoom percentage (25%), as well as the colour mode and bits per channel (RGB/8).

Opening a blank canvas 🛦

Go to File > New and a pop-up window will ask the size, resolution and mode of a new canvas. Set the image as an A4 page in the Preset box, the Resolution at 300 pixels/inch (or dpi) and the Color Mode to RGB Color. In Background Contents select White. Click OK and an active window with a white canvas will appear. It is possible to have several canvas windows open simultaneously, but only one is active at any given time.

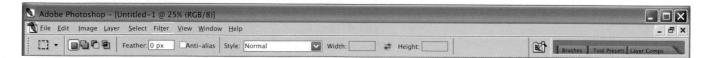

The Menu Bar 🔺

This is directly below the Title Bar, and includes options such as File, Edit, Image, Layer, Select, Filter, View, Window and Help, just like other standard applications. The Photoshop menu also uses the same keyboard shortcuts, for example, the [Alt]+F will select the File menu, or click on a menu name to see its drop-down menu.

The Options Bar 🛦

This appears below the Menu Bar and displays the options for the currently selected tool. The above example shows the Rectangular Marquee Tool options.

The toolbox ▶

Normally the toolbox is on the left of the window. but if it is not visible, go to Window > Tools to display it. The toolbox is a convenient way to choose tools for working on images in Photoshop. To select a tool, click on its icon in the toolbox. Only one tool can be selected at a time, and only the primary tools are readily visible. When a tool is clicked on, the button will 'stick' to show it is selected. In the example on the right, the Zoom Tool (indicated by the magnifying glass) is currently in use. The cursor's pointer will also change shape to reflect which tool is currently in use.

Palettes >

These are indispensable components of the tool set. They supplement the toolbox with additional options. On first opening Photoshop, the palettes are stacked along the right side of the screen in palette groups. By default, there are four palette groups:

The first group is the Navigator, Info and Histogram. The second is Color, Swatches and Styles. The third is History and Actions. At the bottom are the Layers, Channels and Paths palettes.

The default settings can be modified by clicking on Window on the Menu Bar and selecting the palettes that you wish to display. Dragging the Title Bar of each palette window allows you to place it anywhere within the Photoshop window.

Each palette has a Palette Menu Button (a small arrow) in the upper right corner, which, when clicked, displays a drop-down menu with options for that specific palette.

The most commonly used palettes are History and Layers. The History palette is an 'Undo' list of every step taken in the current Photoshop session. Selecting a step in the sequence restores the image to that stage and steps can be deleted as required. Layers are useful for organization and editing and are explained later in this chapter.

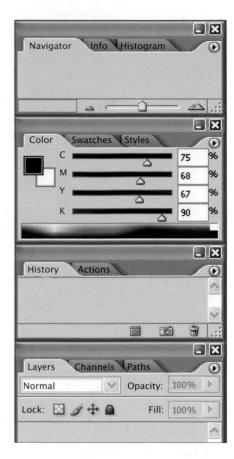

A digitized illustration

Digital colour grants you a near-infinite palette of colours that remain bright and unmuddied, even when mixed. Colouring can be bold or finely detailed, results can be exported to the page or web, and custom palettes can be saved and reused for multiple illustrations.

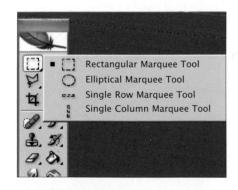

Toolbox options A

A small triangle in the lower right corner of a tool icon means it has more options. To see these options simply click and hold the tool icon for a few seconds, and the alternatives will appear in a pop-up menu. Once a tool is chosen from the pop-up menu it becomes the default tool for this group, until you select another.

Foreground and background colours

These two overlapping squares, near the

bottom of the toolbox, are used to select the foreground colour (front square) and the background colour (back square). Click on the foreground colour square and a colour palette window will pop up and the colour required can be chosen from the slider. The process is repeated to select a background colour. The arrow in the upper right corner swaps the foreground and background colours over, and the small black and white icon in the lower left corner resets the colours to the black and white default.

View and selection tools

The view and selection tools are used to choose particular areas of the art to work on or manipulate. They can be switched from one to the other by pressing the shortcut Function [fn] key on a Mac, and then pressing the relevant letter in the text below. Pressing [fn]+T selects the Hand Tool. On a PC, press the appropriate letter.

Hand Tool (Mac = T) [PC = H] This time-saving tool is used to drag the image around when zoomed into a picture that is larger than the viewing window. Pressing down [spacebar] while dragging with the mouse has the same effect.

Zoom Tool (Z)

The Zoom Tool allows zooming in and out of images. Click the image where you want it to centre and then zoom in, or hold the [Alt] key while clicking to zoom out. You can perform the same function by using the Navigator Palette.

Move Tool (V)

This tool moves an area selected by the Marquee or Lasso tools, or an entire layer when nothing else is selected. Hold the [Shift] key to limit the movements to vertical or horizontal.

Eyedropper Tool (I)

This tool selects whatever colour the pipette icon is clicked on and makes it the foreground colour. Holding the [Alt] key when clicking will make it the background colour. When using the Brush Tool, press down the [Alt] key while clicking on a colour for the same result.

Rectangular Marquee Tool (M) ▶

Use this tool to make rectangular or square selections on images. While this tool is active only the areas within the selection can be affected by other tools or actions. To make a perfect square hold down the [Shift] key while dragging the selection. Clicking the little triangle in the corner offers up different tools in the group: Elliptical Marquee, Single Row Marquee and Single Column Marquee. Each of these will make different regular-shaped selections.

Polygonal Lasso Tool (L) ▶

The Lasso tools are used to select an irregular area. In the drop-down menu you can find another two types of Lasso tools: Lasso and Magnetic Lasso. A lot of people find the Polygonal Lasso Tool, with its straight-edged selection, easier to control than the freehand Lasso Tool. To close the selection made by the Polygonal Lasso Tool, click on the beginning point or simply double-click. If your image has high-contrast edges, then you can use the Magnetic Lasso Tool, which automatically snaps to these edges.

Magic Wand Tool (₩) ▶

The Magic Wand Tool is used to select a colour range, either as a block of colour or as a transparency. The settings for this tool can be changed in the Options Bar at the top. Adjusting the Tolerance value (0 to 255) allows selections to be more, or less, precise. A low number will select only colours that are very similar to the pixel clicked on; a high number will select a wider range of colours. Check 'Anti-alias' to create a smooth edge to the selection (at other times keep it switched off),

Tip: The Lasso Tool creates freehand selections, but by holding down the [Alt] key, straight lines can be drawn.
Conversely, while the Polygonal Lasso Tool normally produces straight-edged selections, you can draw freehand selections by holding down the [Alt] key.

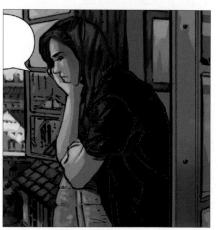

'Contiguous' to select only adjacent areas, and 'Use All Layers' to select areas from all layers. Uncheck them when necessary. Add to or subtract from the selection by pressing down the [Shift] or [Alt] keys.

Select and transform

This example shows how to select a character's eyes and make them bigger using Free Transform. This allows the area selected to be transformed in any way. Instead of choosing different commands (move, rotate, scale, skew, distort, perspective and wrap), a key on the keyboard is held down to switch between transformation types.

Opening the image >

First, open the scanned line art and convert it to a colour file. The eyes are not big enough for a manga character, so they will be enlarged.

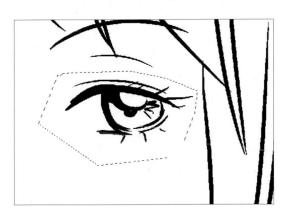

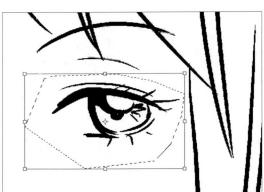

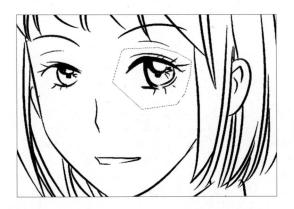

Selecting the area

The Polygonal Lasso Tool selects an area around one eye. For line art, you may wish to use the Magic Wand Tool to erase selected areas of white (leaving only the black selected) so that your enlargement does not erase its surroundings.

■ Transforming the eye Click [Ctrl]+T to select the 'Free Transform' command (or go to Edit > Free Transform). A rectangle will enclose the shape made by the Polygonal Lasso Tool.

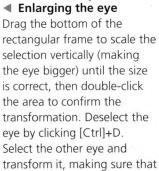

both eyes match.

Tip: When Free Transforming a selected area of an image, if a middle point is clicked, the area can only be scaled up or down. If a corner is clicked and dragged the image can be distorted in any direction. Holding down the [Shift] key and clicking and dragging a corner keeps the selected area in proportion.

Finished eyes ▼

When colouring from line art, it is best to reconvert your Free Transformed image back into a black and white bitmap, then to a colour image again, before attempting to shade it. This keeps all of the black lines crisp and unblurred.

The paint tools

In Photoshop, Paint Tools are used to draw in freehand. There are a wide variety, including Paint Brush, Pencil, Airbrush, Paint Bucket and Eraser. These tools can be used to create manga digitally or to enhance and colour black and white artwork that has been scanned in. These are the most

important tools required to create comic pages on a computer. Each one has an important function and can be altered to an individual artist's preferences. However, a good manga artist will need to learn how to use all of the Paint Tools in order to create exceptional artwork.

The Brush Tool

This tool shares the same button with the Pencil Tool. The Brush Tool is the most commonly used tool when creating a digital manga page. The edge of Brush Tool is softer and slightly more transparent when compared to the harsher line of the Pencil Tool. There are also quite a few different options in the Brush toolbar. Instead of the auto erase of the Pencil Tool, there is Flow and Airbrush, which are explained in the section that follows.

Mode ▼

This is the blending mode of the brush. For most brush work, 'Normal' is the best setting. Experimenting with various mode settings can create unusual effects, often replicating natural media.

Brush variety >

Using a mixture of sizes, opacities, shapes and textures helps render different materials more naturally, as shown here. Softer brushes on the faces contrast with sharper shading on the boy's jacket.

Opacity ▼

The Opacity defines how transparent the brushstrokes will be. An Opacity of 100% is completely opaque, while an opacity of 0% is no paint at all. Your brush will paint with the same level of Opacity as long as the mouse/graphics pen is not released, in which case drawing over a previously brushed area will build up the Opacity and colour. This can provide you with a useful way to vary tones.

Flow V

The Flow determines how quickly the paint is applied at your chosen Opacity. When the mouse button/graphics pen is held down on an area, the Opacity of the colour will build up, based on the Flow rate, until it reaches the set Opacity level.

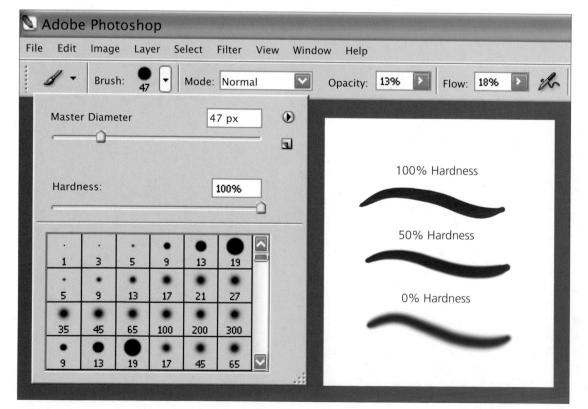

Brush

The size, hardness and shape of the brush can all be altered to taste. The Hardness slider defines how sharp the edges will be. When you are drawing black line work on a manga page, it is best to use 100% Hardness. but a dreamy atmospheric painting in colour would require a very low Hardness setting. The Master Diameter sets how wide the brushstroke will be in pixels.

Brush settings

The Brushes Palette is revealed by either clicking on the Options Bar icon, or selecting Window > Brushes. This palette provides greater control over the brush settings. There are two columns of settings: On the left are the brush stroke options and on the right are the specific settings for each brush option. The right column changes according to

the option clicked in the left column. At the bottom is a preview window that reveals what the chosen brushstroke will look like.

Tip: Once a brush has been created it can be locked by clicking on the padlock icon to prevent accidental changes.

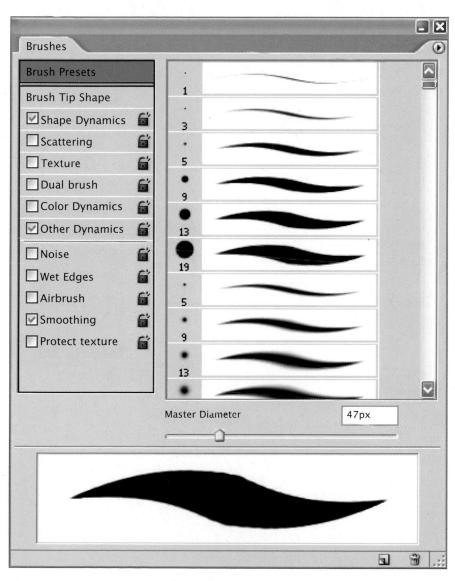

Selecting brush settings A

There are numerous ways in which brushes can be set up to create effects. For instance, choosing 'Wet Edges' with 10% Hardness and a 30px Master Diameter will create a watercolour-effect brushstroke. For the best results when drawing manga line work, select 'Smoothing' and 'Shape Dynamics', with Size Jitter set to Pen Pressure 0%. This brush setting produces very clean lines that respond well to a graphics pen's pressure. For more stylized line work, or colour art, try out a variety of different options in this palette. The trick is to experiment and to have fun.

The Airbrush Tool

As the Brush Tool is so adaptable, the Airbrush is no longer such a unique tool, and now appears in the Options Bar. The main difference between the Airbrush and Paintbrush is that when the mouse button is held down on the former, a constant flow of paint appears, just like holding down the nozzle of a can of spray paint. This paint builds up gradually and is good for creating softer, lighter images.

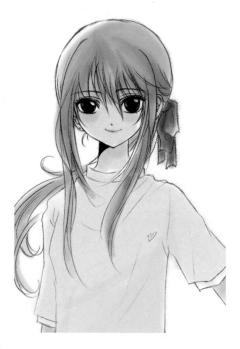

Soft strokes

This soft-focus image was created using a variety of brush shapes and sizes, building up layers of colour, each with a maximum Opacity of 50%.

Tip: The Pencil Tool draws sharp-edged lines. Unlike the Paintbrush Tool, the Pencil has neither subtle tones nor soft edges; it is either 100% colour or not at all. When painting manga pages it is best to avoid using the Pencil as the edged lines look stiff and jagged, especially at lower resolutions. Nevertheless, the Pencil Tool is still useful for clean unfuzzy lines, particularly when creating digital animation and pixel art, such as small icons and mobile games.

The Paint Bucket Tool

This tool is used for filling in selected areas, or areas based on colour similarity to the pixel that is clicked. The Paint Bucket Tool will use the foreground colour as the default, but this can be altered to a pattern selected in the Options Bar. Mode, Opacity and Tolerance can also all be tweaked and tinkered with there.

Tolerance ▼

The Paint Bucket Tool's Tolerance ranges from 0 to 255. A low tolerance means only very similar colours will be affected while a high tolerance means more pixels are selected. A tolerance of 0 selects only the exact same colour as the clicked pixel. If the level is 255, then all colours will be selected.

Anti-alias ▼

Use sparingly, but checking this makes edges of colour smoother by blending with adjoining pixels.

All layers ▼

Checking this fills all layers with your current option, otherwise only the current layer will be filled.

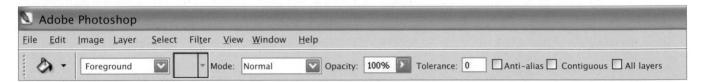

After checking or unchecking the Antialias and Contiguous, and All layers options, choose a foreground colour and click on the area required. When filling solid black or colours in manga linework, the lines must be perfectly enclosed; otherwise paint will escape through the gaps of the area being filled. If this happens, using [Ctrl]+Z will undo the mistake. Check where the gap is and seal it using the Pencil Tool. Alternatively, fill using a selection.

Contiguous A

When selected, only pixels connected to the clicked pixel are affected. Otherwise, all pixels in the image within the tolerance range are filled. Useful for replacing one colour with another.

The Gradient Tool

This tool shares the same button with the Paint Bucket Tool, but it doesn't fill with solid colour. Instead, it creates a gradual blend between colours. It is useful when you want to create things such as metal or sky, and works on a selected area or layer. To create a gradient, a style needs to be selected in the Options Bar. There are five basic styles to choose from: Linear, Radial, Angle, Reflected and Diamond.

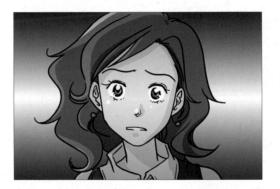

■ The eyes have it

The use of a Reflected gradient in the background focuses the reader's attention on the girl's surprised eyes, emphasizing her emotional state and the tense mood.

Linear gradient A

Create vertical, horizontal or diagonal gradients in this style. Click, hold and drag the cursor, and release it when you have covered the area required.

Radial gradient A

This style of gradient creates a circular pattern. Click and start dragging from where the centre of the radial is required. A longer line creates a whiter circle.

Angle gradient A

This gradient creates a 360-degree sweep of colour, back around to the starting point. It may not often be useful for colouring manga characters and backgrounds.

Reflected gradient A

This is a symmetrical Linear gradient. It is sometimes used in manga to show a character's shock or surprise (as in the example above).

Diamond gradient A

This style creates a star-shaped pattern, formed in the same way as the Radial gradient. You are able to control each colour in the mix.

Colouring the gradient

Once the Gradient style has been chosen, the colours must be selected. The Options Bar holds numerous combinations, including the default, which uses the current foreground and background colours. Changing these will define any two colour gradients. For a more complex combination - perhaps a rainbow-like gradient, for example - double-clicking the colour bar reveals the Gradient Editor window. Double-clicking the colour stops along the colour belt allows the colours to be customized; dragging their positions alters where they blend. Clicking anywhere under the belt adds another colour stop.

Paint a rainbow

It is possible to make gradients up of as many colours as desired, by adding or removing colour stops and dragging them up and down the colour bar. These customized gradients can be saved and used at a later date.

The Eraser Tool

This tool is the opposite of the Pencil/Brush tools. The Eraser's Modes can be set in the Options Bar to softedged brush or airbrush, hard-edged pencil or square block. Pixels are erased to transparency, or to the background colour on a locked layer.

In the Eraser Tool's Options Bar there is an option called Erase to History. When this option is checked, instead of painting to a transparency level or the background colour, the Eraser paints from a History state or from a snapshul set in the History Palette, allowing you to repaint erased areas.

The Opacity and Flow of the Eraser Tool can be defined in the same way as the Brush Tool.

Tip: To create a snapshot in the History Palette, just check the little box on the left of the stage you want.

Magic Eraser Tool and Background Eraser Tool ▶

There are two other tools sharing the same button with the Eraser Tool: the Magic Eraser and the Background Eraser.

This tool is useful when removing colour from line work, if they have been merged by mistake. It works in a similar way to the Magic Wand Tool, but instead of making a selection, it makes clicked pixels transparent. Options such as Tolerance and Contiguous are just like the ones in the Magic Wand Tool.

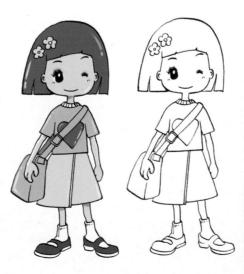

Background Eraser Tool ▼

Magic Eraser Tool

TEraser Tool

You can also erase more complicated (gradated) backgrounds to transparency using this tool, by sampling the colour in the centre of the brush continuously. Make sure the Cross Hair remains outside the edge of the areas that need protecting, so it won't sample that colour and erase it.

Background Eraser Tool

Other useful tools

Apart from the previously mentioned Paint Tools there are many other tools that will aid the creation of excellent manga art. Most of these, like Clone Stamp, Blur, Sharpen, Smudge, Dodge, Burn and Sponge, affect existing drawings, rather than originate them, and can be used for a wide variety of effects. Dodge, Burn and Sponge can be used to create highlights and shadows, while the Smudge Tool allows the artist to handblend colours like digital pastels.

The Clone Stamp Tool

This tool copies a section of an image on to another part of the picture or on to a completely different image. Using the Clone Stamp Tool in manga drawing allows the artist to paint tones or patterns on to a manga page underneath or on top of existing artwork. Once mastered, it is a fantastic time-saving device for making duplicates.

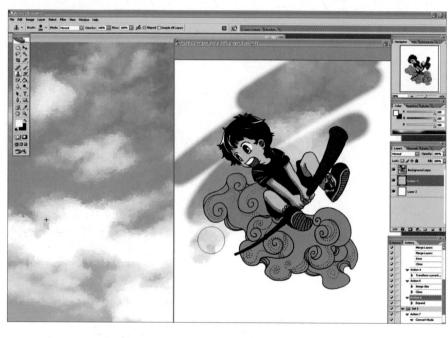

■ Using the Clone Stamp Tool

After [Alt]+clicking the part of the image that needs be cloned from. creating a sampling point, it is simply a matter of painting directly on to the area that needs to be cloned to. Normally the 'Aligned' option in the Options Bar is checked, so the sampling point moves simultaneously with the painting cursor's movement and the new cloned image is drawn continuously. If this is not required, uncheck the 'Aligned' option. This will make the clone brush begin drawing again from the original sampling point each time the mouse button/pen is released. If the 'Use All Layers' option is selected, then all the image's layers will be cloned from the source. Otherwise, only the currently active layer is used.

The Blur and Sharpen tools

Different uses for Blur and Sharpen

These two easily controllable tools can be used in various ways, from sharpening up out-of-focus scanned-in line art, to deliberately blurring a figure in order to push the figure into the background, creating an impressive 'photographic' effect.

Blur Tool ▶

The Blur Tool blurs image areas by reducing the colour contrast between pixels. In the Options Bar the 'strength' can be altered. The 'Sample All Layers' option affects all layers; otherwise, only the current active layer will be blurred. The Blur Tool is usually used to soften the edges of colours so that they merge together smoothly.

Sharpen

Blur

◀ Sharpen Tool

The Sharpen Tool is the opposite of the Blur Tool. It increases the contrast between pixels, thus sharpening the focus.

Tip: Pressing the [Alt] key while dragging in Blur mode, will sharpen the image, while [Alt] key and dragging within Sharpen mode will blur it.

Sharpening line work Sometimes scanned-in line work can be a bit blurred. The Sharpen Tool can gradually sharpen the line art, but rescan if necessary.

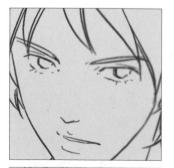

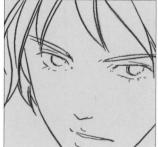

The Smudge Tool

Using the Smudge Tool is like smudging a wet painting with a finger, just as the icon of this tool indicates. This tool uses the colour where the stroke begins and spreads it in the direction in which the tool is dragged. This is very useful for drawing natural-looking hair. Try different strength settings to see what's best for your drawing.

Smudged hair ▶

Individual smudged strands of hair produce a wilder, more natural look.

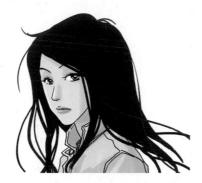

The Dodge, Burn and Sponge tools

These three toning tools get their names from traditional photography methods and share the same button. These tools all use customizable brushes, just like the Brush Tool. Often they are used on fully painted manga, rather than black and white line art, and create a softer, three-dimensional look. The Dodge Tool lightens up areas of an image. It is very useful for adding a light source quickly to a flat-colour manga character. The result will not be as good as the normal Brush Tool, because the Dodge Tool washes out colour and details.

The Burn Tool is the opposite of the Dodge Tool: it darkens the area it is dragged over. Normally it is used for adding shadows guickly. Again, the result is not as good as using the Brush Tool. The Options Bar is the same as that for the Dodge Tool.

The Sponge Tool has two modes: Desaturate and Saturate. While in the Saturate mode, the Sponge Tool adds colour saturation to the areas dragged over. In Desaturate mode it does the opposite. In a greyscale picture, it increases or decreases the contrast.

Dodging and burning manga art ▶

These examples show how the Dodge and Burn tools can be used on a flatcolour character (left) to create shadows and highlights (right). The colour on the girl's right arm has been washed away by the Dodge Tool, to create the highlight.

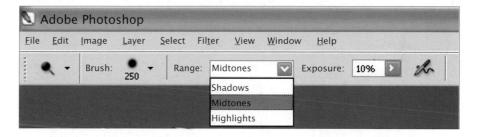

Selecting a range A

In the Options Bar, there are three ranges to choose from: 'Highlights', 'Midtones' and 'Shadows'. If 'Highlights' is selected, only the lightest areas will be affected, and so on. The 'Exposure' level decides how intense the effect is; this is usually set at a low level: between 10 and 50%.

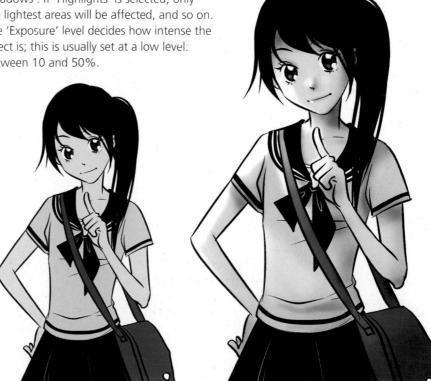

Photoshop layers

One of the most powerful features of Photoshop is layers. Traditional manga would occasionally use semi-transparent acetate paper laid on top of the artwork to draw and letter the speech balloons on. This allowed for the lettering to be moved around and the language and style to be changed without affecting the original art. This is now done digitally, using

layers; but layers are also perfect for adding colour, gradients, tones and more. Because of layers, each layer can be changed independently without affecting the others, allowing complex images to be created. Imagine each layer as a clear plastic sheet with part of the image printed on it, all of which are stacked to make the complete picture.

The layered image

After creating a new canvas, or opening any image, there is already at least one layer in the Layer Palette. The image portrayed below shows how layers work; each individual element on its own separate layer, allowing them to be edited independently.

Tip: Always add new elements on a new layer. This way the original image can be preserved. Doing this allows for easier editing of mistakes. The layers can always be merged at a later stage, if the end results are satisfactory.

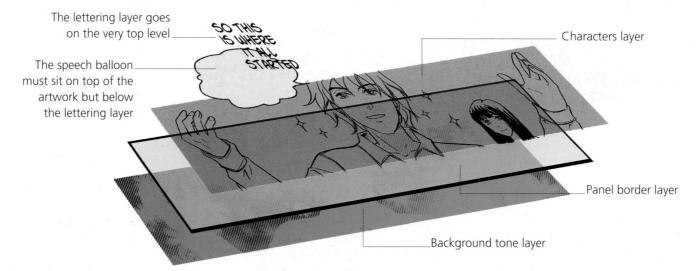

Shuffle the deck A

The layers can be arranged in any order, allowing a character to be pushed into the background or an object to be brought into the foreground at the click of a button.

Invisible layers >

When the final artwork is seen, the layers are invisible, or flattened into a single layer, so although the characters, the background tone, the dialogue bubble, the text and the panel border are all on separate layers, the reader sees the image as a unified whole. Always save the files as layered .psd files for future editing.

Removing lettering

After this panel was lettered it was decided that it would be better with no dialogue. In the past, this would have

been a huge problem. The speech balloon would have had to be covered up or cut out, and then the background tone would have been added to match the art exactly where the balloon was. Using Photoshop's layers, the balloon and text are created on separate layers and are thus easily deleted.

The Layers Palette

Layers are controlled through the Layers Palette (Window > Layers). On the palette, each layer is displayed as a small thumbnail, with the name of the layer next to it. The final appearance of a layered Photoshop image is the view from the top, down through all the layers. The order of the layers in the Layers palette represents their order in the image.

New/duplicate layer

Clicking this icon creates a new layer above the current active layer. Duplicate a layer by dragging it on to the icon. The new (duplicated) layer appears on top of the previous one.

Layer via copy, cut or drag

To copy or cut part of a layer to make a new layer, simply select the area required and the option 'Layer via copy' or 'Layer via cut'. The new layer with the selected area will appear on top of the original layer. Dragging and dropping a layer on to an open image is also possible.

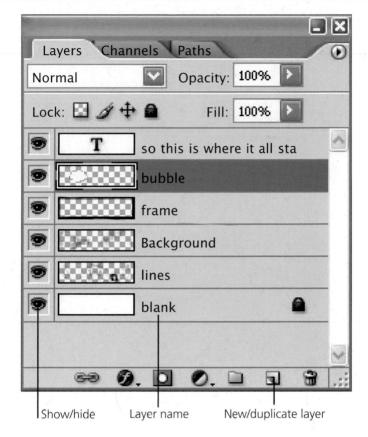

Naming layers A

Double-click on the default layer name to rename the layer as something more memorable.

Changing the layer order ▲

To change the layer stacking order in the Layer Palette,

just click and drag it up or down the stack and place it where it is needed.

Deleting a layer A

To delete a layer, simply drag the layer to the Bin icon at the bottom right of the palette. Don't do it unless the layer is never needed again.

Hiding layers

Sometimes it is useful to hide a layer in order to be able to concentrate more easily on the layers underneath. Clicking (and removing) the eye icon makes the layer temporarily invisible. Clicking the eye again makes the layer visible once more.

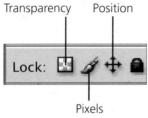

To avoid working on the wrong layer they can be locked as follows:

Transparency: Once checked, it is impossible to paint on transparent areas.

Pixels: Once checked, cannot be drawn on.

Position: Prevents the image on the layer being moved, but all other functions work.

All: Stops all editing.

Layer-blending modes

Each layer has its own blending mode, which allows one layer to blend with the layers underneath. Under the Layer Palette's default setting, 'Normal', is a list of blending modes in the drop-down menu. Along with 'Normal', the other most commonly used blending modes in digital manga creation are 'Multiply' and 'Screen'. The examples here reveal their effects. The red heart is the upper layer, the purple heart the lower. Don't forget that the Opacity and Fill of a layer can also be changed using the sliders on the Layer Palette.

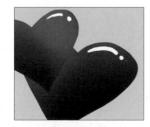

Normal A

The upper layer displays the full colour value and the image on the layer underneath is covered.

Multiply ▼

This multiplies the upper layer's colour intensity, so the lower layer gets darker. The upper layer's white becomes clear.

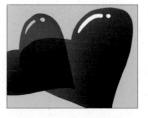

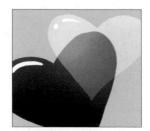

Screen A
Darker colours in the lower layer appear lighter when this is applied to the upper layer.

Scanning and retouching an image

Hand-drawn pictures can be processed digitally by importing the image into the computer using a scanner. This is extremely convenient for artists who prefer the feel of working with pen and paper, but still want the advantages working digitally can offer. Large areas of black shadows can be added quickly using the Fill Bucket Tool, saving hours of laborious inking, and any smudges or mistakes can be easily removed and cleaned up. The other advantages are obvious. The drawing can be coloured digitally without affecting the original artwork; and it can be emailed or posted on the Internet and shared with millions of people: all impossible without first being able to scan in a paper drawing.

Practice exercise: Scanning, adjusting and cleaning an image

Here is a quick guide to scanning in simple line work, the most common requirement for a manga artist. The higher the dpi, the bigger the file will be when scanned in; but the quality of the picture will also improve, thus you can get into more details of the image and can print out bigger pictures later.

Place the drawn image face down on the glass in the scanner, aligned with its edges.

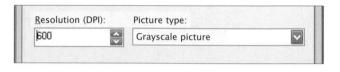

In Photoshop, choose File > Import to open the scanning software. Choose 'Grayscale picture' (if scanning in a colour image, choose 'Color') and set the resolution to 600 dpi.

Click 'Preview' and wait for the scanner to show a preview version of the image. Select the area in the preview image required to scan, then click 'Scan'. The picture will be scanned in and appear in a new Photoshop window.

3 Go to Image > Mode, and change the image to Grayscale (if grey tones are needed), or RGB, if working in colour later. Click File > Save as... to

save the file as a .psd file and give it a new name. The image is ready for further adjustments. The lines in this example are too grey and not black enough. To adjust this, go to Image > Adjustments > Levels to open the Levels window. Sliding the three pointers controls the image's amount of black, white and grey.

Watch the changes on the original image and when the lines become solid black and are still delicate. Click OK.

Tip: Sometimes part of the line work might be very light, and adjusting the Levels may cause these light, fine lines to disappear. Use the Burn Tool to darken them before using the Levels adjustment.

Tip: A shortcut to balancing the black and white is to go to Image > Adjustments > Levels and in the window check the black Eyedropper Tool. Then click on the blackest part of the line art. Repeat, using the white Eyedropper Tool, clicking on the whitest part of the image. This will remove most of the mid-tones.

5 Now use the Eraser Tool to clean up the remaining dirty dots and anything else that needs removing from the image. Using a fine point, you can sharpen lines to details that would be impossible with an actual pen, if you so wish. Details can also now be added to the image, using a tablet pen or mouse. This is the perfect time to tweak and hone the picture until the line work is just right.

Practice exercise: Separating the line art from the white background

It is good practice to separate the black line art from the white background so that the line work can be manipulated at a later stage, such as changing the colour of the lines or even altering the lines after feedback from friends or colleagues. It also allows for additional colour layers to be added underneath, ensuring the black line art is always on top, like an acetate sheet over a painting. Here is the quick and simple method of separating the line art from the background.

Tip: Channels visibility can be turned on and off, like the Layers. In RGB and CMYK mode this allows different colours to be switched on and off, giving interesting alternate hues.

1 On the Layers Palette, click the 'Channels' tab to activate the Channels Palette. Initially, there is one layer called 'Gray'. Duplicate this layer by dragging it to the 'Create new channel' icon at the bottom of the window. Go back to the Layers Palette and create a new layer. Next, delete the original layer with line art on.

3 Use the Paint Bucket Tool to fill the selection with black. Underneath this layer, create a new layer and fill it with white using the Paint Bucket Tool. A separate layer for the line work has just been created.

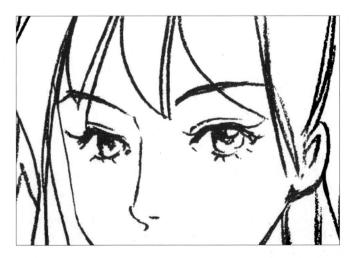

4 Because the line art is on its own layer, with a transparent background, the Lock Transparency icon can be clicked.

If this is checked, the Brush Tool can only draw on areas that

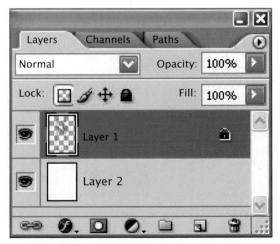

are not transparent, meaning only the actual line work itself. Switching to RGB mode will allow the lines to be changed into any colour.

Digital inking

It is becoming increasingly popular among manga artists to use digital inking. This method allows manga artists to draw perfectly smooth and crisp lines without worrying about making mistakes. There are several ways to digitally ink a pencil sketch. Traditionally the manga artist creates a new layer on top of the sketch and effectively 'traces' the sketch, adding subtle changes, shading and nuances. A cruder method is to simply convert the image to a grayscale and in Image >

Adjustments > Levels open up the Levels window. Here, adjust the black and white levels by sliding the pointers up and down until the background is pure white and the lines are no longer grey, but solid black. However, if there is too much white, delicate lines will be lost. Conversely, too much black will make the artwork look thick and blobby, with no variation in the thickness of the line. It is always recommended to ink the page in the first manner to add vitality to the art.

Practice exercise: Inking a scanned image

It is a good idea to have practised inking on paper, as shown earlier in the book, in order to get a feel for drawing smooth lines with a real pen. Inking in Photoshop with a graphics tablet pen can be done in several ways. A pencilled image can be scanned in or you can sketch directly into Photoshop. Because the 'ink' is usually 100% black, it is best to have your pencilled image as a lighter shade, so you can see what you have already inked.

Tip: Practise a variety of brushstrokes on smaller pencilled studies with either a mouse or a graphics tablet pen before attempting to ink an entire image.

1 Before inking, a sketch is required to work on. This example is a scanned-in greyscale image at 600 dpi. Alternatively, a sketch can be created straight on the screen using the graphics tablet. Switch the image's Mode to Grayscale, rather than RGB, as the files are smaller, thus making the computer run faster. If colour is needed later, the image's mode can be changed back to RGB once the inks are complete. Create a new layer and call it 'inks'. This is the layer that will be digitally inked on. Set the Mode to 'Normal'.

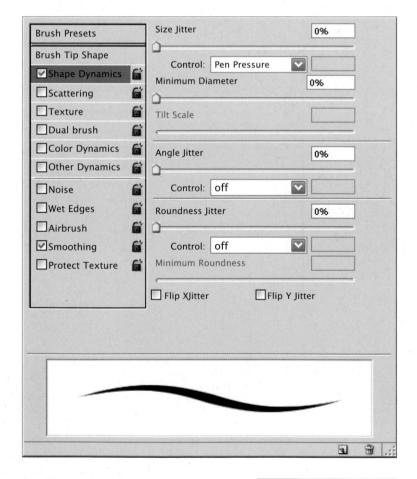

2 Choose the Brush Tool. Open the Brush Palette, check 'Shape Dynamics' and 'Smoothing', and in the setting for Shape Dynamics, set the Size Jitter to Pen Pressure 0%. Choose a round brush and set the Hardness to 100%. Vary the line width while working.

Tip: Pressing D will reset the default foreground colour back to black, and the background colour back to white.

On the 'inks' layer, begin drawing over the pencil lines. Use thinner lines and vary the brush sizes for small details and relatively thicker lines for longer strokes. Occasionally, the pencil design may be weaker than you originally thought: this is a good time to make any alterations on the 'sketch' layer. In this example, the details of the man's hands and face were tightened and the anatomy strengthened.

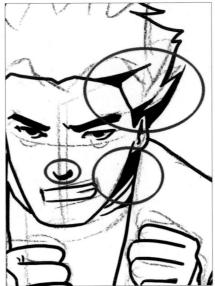

Finish the basic inking, making sure nothing is missing. Go back and ensure there are ample details to enrich the picture. Here, thicker shadows have been added in the hair and on the face in order to indicate depth. If the 'sketch' layer has become too messy and it is difficult to see where to ink, create a new layer between the 'inks' and 'sketch' layers and fill it with white, in 'Normal' mode. Turn this middle layer on and off and your inking progress can be checked easily. Varying the thickness of your lines and shadows enhances the depth of the image. The thicker the lines, the heavier and more solid the object will look; the thinner the lines, the more delicate the object will look.

Use the Paint Bucket Tool to fill in solid black areas. The Brush Tool's stokes have soft edges, and they appear slightly grey. Because of this, when using the Magic Wand or Paint Bucket tools, they may not be able to select the whole area (experiment with Tolerance first). Instead, there may be a tiny belt of white between the selection and the surrounding brushstroke line. To correct this, select the area that needs filling, then go to Select > Modify > Expand and expand the selection by one or two pixels. After this expansion, the selection will cover the white belt area and the area can now be filled in with the black colour.

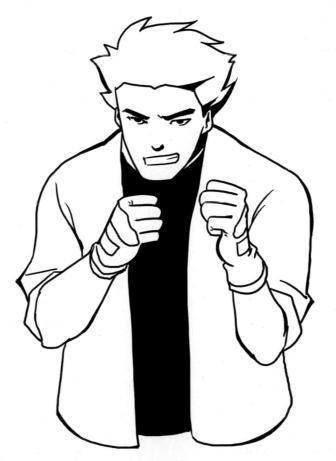

Tip: Remain stable when using the graphics tablet pen, and don't shake too much. It can be difficult, especially drawing longer lines, but with practice, your stability will improve considerably. Some lines will need a few attempts to get them right. If a mistake is made, use [Ctrl]+Z to undo it. The Eraser Tool can also be used to remove mistakes or sharpen blunt lines.

Once satisfied with the inking, delete the 'sketch' layer. There will be two remaining layers left; the line art layer and the layer filled with white as background. The image is now ready for further developments.

Toning techniques

The majority of manga books are in black and white, and consequently grey tones are a manga artist's essential tool. Grey tones add shadow, lighting, texture and depth to black and white line work, essentially forming the 'colour' of black and white manga. The traditional way of adding grey tone, still practised by many modern Japanese manga artists,

is to use rubdown Letratone sheets. This involves selecting the appropriate-size grey-tone sheet, pasting it to the original artwork, then using a blade to cut carefully around the artwork. It is expensive, time-consuming and requires a lot of practice. Thanks to Photoshop, the digital alternative is much quicker, cheaper and easier.

_ X

Practice exercise: Adding tone

Adding tone to a line image is very simple, but can be incredibly effective in enlivening a basic manga line drawing. Essentially, it is the same as adding colour using the Paint Bucket Tool, with the blues, greens and yellows being replaced by various shades of grey.

1 Open the image. This should have two layers: one white background and one for line art. Ensure the image is in Grayscale mode. Create a new layer between these two layers and set the mode to 'Normal'. Call this layer 'tones'. Go to Window > Color to reveal the Color Palette. The Color Palette contains only one slider scale; from white to black. It is better to pick a grey tone in the Color Palette, rather than the Color Picker on the Toolbox, because it is possible to define the exact percentage of grey required. The grey tones are defined as 0% being pure white

and 100% being solid black, therefore 50% is an exact grey. The lower the

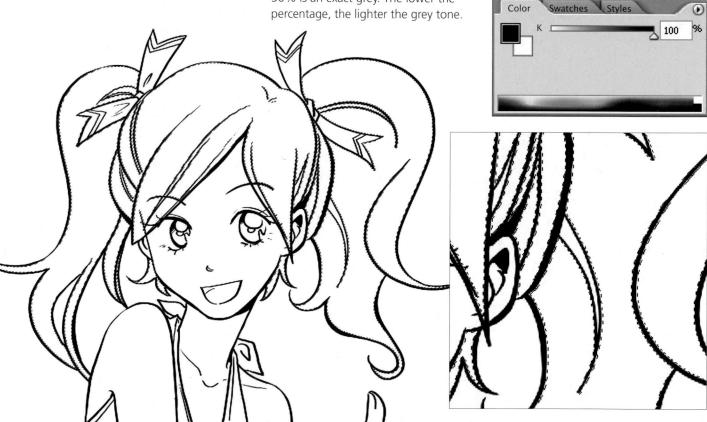

2 Use the Magic Wand Tool to select the girl's hair. Check 'Contiguous' and 'Sample all Layers' in the Options Bar. If there is a gap in the line art, then the Magic Wand Tool will select more than required, in which case, the area needs to be deselected ([Ctrl]+D) and the gap joined using the Brush Tool. Alternatively, you can trim areas from the selection using the Lasso tools and the [Alt] key. To select multiple areas, press down the [Shift] key while selecting the area. To deselect an area from the current selection, press down [Alt]+click.

Zoom in on the selected area. If the grey tone is filled in now, when the selection does not exactly butt up with the line art, there will be a terrible white gap between the grey and line. To solve this, go to Select > Modify > Expand and expand the selection by one or two pixels. It is important to make sure the edge of the selection is actually just underneath the line art, so if the first pixel expansion is not enough, increase it by another one or two pixels.

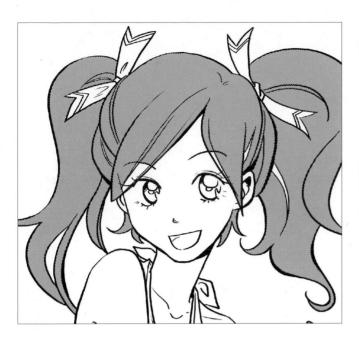

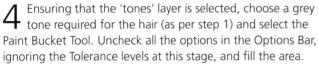

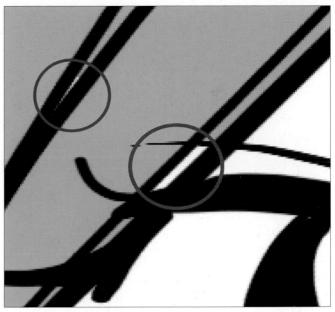

After the grey has been filled in, zooming in may reveal some areas in the hair that have been missed in the selection. Use [Ctrl]+D to deselect the current selection and then use the same selecting method to select the missed areas and fill them in. Zoom in again to confirm all the areas have been filled.

Tip: Always remember that the layered manner of working in Photoshop means that it's possible to 'fix' areas of missing colour quickly and simply, by drawing directly on to the 'tones' layer beneath the line art, which remains untouched. Use the Pencil or Brush tools for exceptionally fiddly areas that may be missed by the Magic Wand Tool's selection process.

Repeat the process with the O other parts of the image. Use the Pencil Tool to apply the grey tones carefully to tight areas where the Magic Wand and Paint Bucket method doesn't work so well, or where it would prove time consuming. Choose complementary shades of grey to give your image the illusion of colour and depth. Push the extremes more than you would in a fullcolour drawing, as you only have 256 shades to work with.

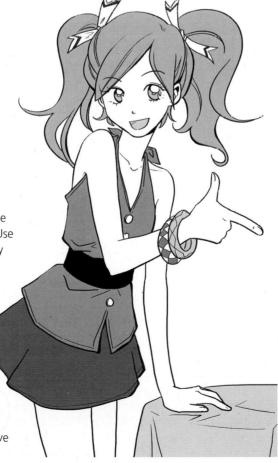

When filling in the areas of the image, don't forget to fill in all the transparent areas within the character, with solid white, including the skin. Turning off the white background layer will give you a clear view of where to fill. The solid white needs to be filled in, otherwise when you come to fill in the background layer, it will show through the uncoloured skin.

Practice exercise: Adding shadow, highlights and pattern

After the toning in the last two pages, you will now have a plainly toned image. Depending on personal taste, for some people this is a finished work.

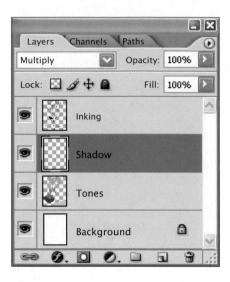

Add a new layer on top of the 'tones' layer and name it 'shadow'. Set the Layers mode to 'Multiply'.

Selecting the areas as before, add shadows to the rest of the image in the same way, paying attention to the way shadows may fall differently on fabrics and skin. Turn off the 'Tones' layer periodically to spot areas you have missed.

For a more professional look, you still need to add further details to the image, building up areas of shadows, highlights and patterns.

2 To add shadow to the hair, go to the 'Tones' layer and use the Magic Wand Tool to select the hair colour. Uncheck 'Contiguous' and set the Tolerance to 0. This will make the Magic Wand select only the hair colour. If you have used the same shade of grey anywhere else on the image, it will select those areas as well, but in this instance, the hair is the only part of the image so shaded.

Next, add highlights to the image. Create a new layer called 'Highlight' on top of the 'Tones' and 'Shadow' layers and set the mode to 'Normal'. Consider your light source, and at the point where the light is strongest, add pure white highlights. You will still need to use the Magic Wand Tool to select each area individually to ensure your highlights don't go outside of the lines.

3 Flip to the 'Shadow' layer. Choose a light grey tone and, within the selection, paint shadows on to the hair. Here the light comes from the top left corner. Use the Eraser Tool to clear up mistakes. Use a darker shade of grey to draw heavier shadows at the darkest points; for example, where an object casts a shadow on another one.

The image could do with a background. Create a new layer underneath the 'Tones' layer, setting the mode to Normal. Select the Gradient Tool and drag a Linear gradient from white to mid-grey over the whole picture. Create another 'Normal' layer on top of this one and choose a softedged, big brush with Opacity of around 50. Paint big white dots to create a dreamy atmosphere. Merge your tone layers together and rename them 'Gray'.

Practice exercise: Converting grey tone to black dots

If you want to publish the previous image online, then we have finished the toning procedure. If, however, you want to publish your image professionally, it is not finished yet. In many printed manga, the grey tones are not grey, but made up of countless black dots. The bigger the dots and the closer they are printed, the darker the grey appears.

Many manga/comic printers don't print colour (mainly for cost reasons), so we need to convert our grey layer to black dots.

Halftone shading ▶

While many printers use halftone screens for their regular output, manga makes an art out of necessity.

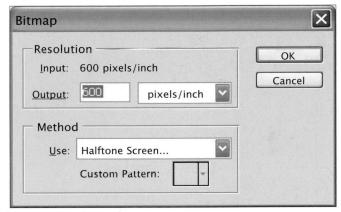

1 Create a new document the same size and resolution as the current one. The current document ('Cutie.psd', above left) is a Grayscale A4 page at 600 dpi. Go to File > New. Choose the appropriate settings in the pop-up window, then click OK. Drag the flattened 'Gray' layer from the layer palette of 'Cutie.psd' (as shown above right) and drop it into the new document. Make sure it fits within the canvas.

2 In the new document, click Image > Mode > Bitmap to reduce it to pure black and white. In the first pop-up window, click OK to Flatten Layer, and in the second pop-up window, choose to output the image at 600 (the current resolution, often used interchangeably as dots per inch and pixels per inch) and select Halftone Screen as your method. Click OK to go ahead.

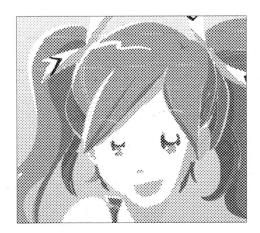

In the third pop-up window, change the Frequency to 32, make the Angle 45 degrees and select Round as the shape. If you want to try out different values or shapes, experiment with a number of different options in case an alternative method takes your fancy. When you have entered the values, click OK. All of the grey tones are converted into black dots.

Tip: If you have the hard drive storage space, it is well worth hanging on to layered .psd files, as you never know when you may need an editable version of your illustration. For instance, if you wanted to create a colour version of this picture, you will regret only saving a merged tiff or jpg file. Layered files are large, so backup your archives to CD or DVD periodically. Don't forget, you can save a flattened jpg to display online by using the File > Save as... command. If saving a large .psd file for the web, you will probably want to reduce the width to between 600 and 9000 pixels so it can be viewed on a monitor without horizontal scrolling.

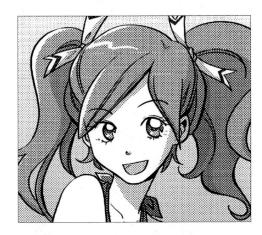

A Now go to Image > Mode > Grayscale to change the image to Grayscale. Set the size ratio to 1 in the pop-up window. Drag the layer back to 'Cutie.psd' and move the shading so that it matches the lines, ensuring it is on top of the 'Gray' layer and beneath the 'Inking' layer. You can now either merge all layers or just save this image as a layered .psd file.

Speedlines and focus lines

The method of creating speedlines and focus lines is often discussed together, as both are used to create an impact on the reader by communicating shock, surprise, tension and movement. Speedlines are a group of parallel (or nearly parallel) lines that show movement, while focus lines are

a group of lines radiating out from one central focal point. They add impetus and interest to a single-colour background especially when something is moving quickly towards the reader's point of view. The effects themselves are easily created in Photoshop, and this tutorial will show you how.

Practice exercise: Creating speedlines

Drawing speedlines the traditional way requires huge amounts of concentration and patience – or a crack team of assistants blessed with the same. Hundreds of lines must be drawn on paper with exacting care, using pen and ruler, with no respite but white-out if a mistake is made. Now, there is Photoshop, which can produce excellent results in a fraction of the time. There are many speedlines available online, ready to paste into an image. If you can't find them online, here is an easy way to make some yourself.

1 Create a new file at the same resolution as the image you will be dragging the speedlines into later (300-600 dpi). Don't make the image too big, just a little bigger than the manga panel you want to cover. Set the file Mode to Grayscale. Use the Single Column Marquee Tool to select a single column on the image, then fill it with the grey tone of your choice.

Go to Edit > Transform > Scale to transform the selection. Drag the selection from both sides, stretching out the single vertical column of pixels to fill the whole page from left to right. Double-click the image when you are finished to confirm the transformation.

With the grey-toned area still selected, go to Filter > Noise > Add Noise. The higher the number you choose, the more intense the speedlines will be

Zooming in on the image will reveal that most of the lines are grey rather than black. To correct this, go to Image > Adjustments > Brightness/ Contrast. Increase the brightness, and turn the contrast level up to maximum. Now the speedlines are ready to use. Paste them into your manga panel and use the 'Free Transform' function to fit the angle you require.

Tip: There are other ways in which you can integrate your speed and focus effects with your colour pages. Try varying the colour of the line, for instance, so that you use a dark purple shade on a light purple background. Alternatively, use the Magic Wand Tool with 'Contiguous' unchecked on your speedlines layer to select all the black lines, then apply a gradient from light to dark in the direction of travel. Finally, try playing around with the layer blend and layer fill Opacity settings: how do your speedlines and focus lines look when blended in 'Multiply' or 'Screen' modes, for example?

Speedlines in action

Compare these four pictures of a running boy. The first lacks impact without speedlines. The second is

'naturalistic', with a speedline shadow and blurring. The third ups the strength (and speed) of the lines, while the

fourth creates a background from them, freezing a moment in time and generating an intense atmosphere.

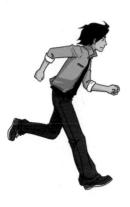

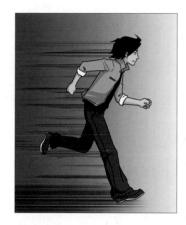

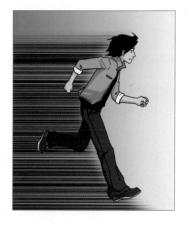

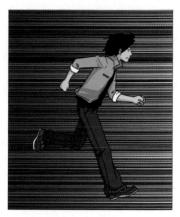

Practice exercise: Creating focus lines

Focus lines are normally used to express tension or surprise. Their nearinterchangeability with speedlines

Use the speedlines you have just created. We need to turn the canvas 90 degrees to make the lines vertical. Go to Image > Rotate Canvas > 90' CW.

Now go to Filter > Distort > Polar Coordinates and bring up the option window. Choose 'Rectangular to Polar' and click OK. Your image is converted to a page of focus lines converging on a central point.

visually also means they sometimes function as 'speedlines in perspective'. In either case, they isolate a character or

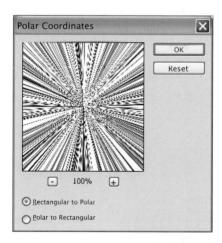

vehicle in the centre of a panel, drawing the reader's attention to it and its current condition.

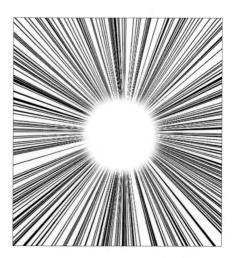

The lines 3 The lines don't usually go all the way to the centre of the image. Use a big, soft-edged Eraser Tool to clear the middle. If you think the focus lines are too crowded, use a hard-edged Eraser Tool to clean up some of the lines.

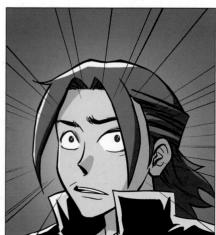

■ Polarized image

This is an example of an image with vertical speedlines after they have been passed through the Polar Coordinates filter.

Style of lettering

Lettering is an essential part of manga, forming half of the interplay between words and pictures that makes manga unique. While the action of your story may be clear from the illustrations, dialogue, captions, speech balloons and sound effects all allow you to dive deeper into your world and the motivations of your characters, as well as adding 'verbal' wit, humour and tension to your tale. Lettering also serves as a guide to the reader through the page: skilfully deployed balloon placements move the eye from panel to panel and control the pace at which a reader consumes the story.

Snappy dialogue and well-placed balloons can often cover up deficiencies in artwork or panel-to-panel storytelling, so never underestimate the importance of lettering. The most common devices to show spoken dialogue are speech balloons: the ellipses containing lettering, with 'tails' that point towards the relevant speaker. Remember to integrate your balloons and digital lettering with your art style – conventional word processor fonts look bland and out of place, so find a font that meshes with your art. Visit www.blambot.com for a selection that are free for personal use.

Placing speech balloons

Dialogue and balloons cannot be simply dumped on to the page; they must be added with the same care and attention to the overall composition that characterized your panel layouts. Remember that balloons should not cover up vital parts of the artwork, and should direct the eye from the top left to bottom right of the page.

Speech balloons in action ▼ ▶

These two panels both show successful balloon placement. Below, an unusual font suggests a non-human character, while the balloon is offset so it doesn't cover up any of the art. The balloon to the right overlaps with non-essential art (the character's hair) in order to fit within the panel bounds.

Practice exercise: Adding lettering

Professionals digitally letter manga in a number of different and esoteric ways. This method, which stays within Photoshop, is the most straightforward, and is suitable for all skill levels and complexities of projects.

1 Open the page you wish to letter in Photoshop and bring up the Character Palette (Window > Character). Choose a font from the drop-down menu at the top left and select a size appropriate to your page from the menu underneath. Make sure your lettering is legible at your final print size.

2 Set your colour to black, select the text tool ([Ctrl]+T) and click where you want to place the text, creating a 'Text' layer where you can type. If you are working from a script, you can copy and paste dialogue on to your page.

Tip: Manga tends to use capital letters for all its dialogue, with bolds and italics for emphasis. If your script is in sentence case, select your text once you have pasted it across, click the small arrow at the top of the Character Palette, and select 'All Caps'.

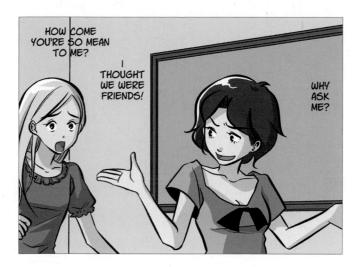

Bach balloon forms a new 'Text' Layer, select each one as required. Centre the text ([Ctrl]+[Shift]+C) and use the Return key to arrange the text into a relatively elliptical shape. Arrange your dialogue blocks so that they don't cover important elements of the image, and they flow from top left to bottom right. Add emphasis to dialogue by making stressed words bold and/or italic. Finally, check that all your important text is well within the boundaries of the page – in case the page is trimmed too close at the printing stage.

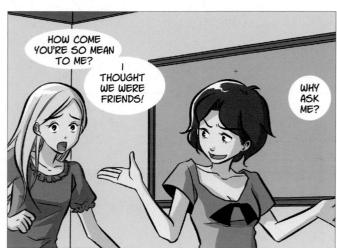

Add a new layer beneath all of the 'Text' Layers for balloons. Set the mode to 'Normal'. Select the Ellipse Tool, checking 'Fill Pixels' in the Options Bar. Set the foreground colour to white. Click and drag the mouse/tablet pen to make white filled ellipses beneath all of your blocks of text, making the balloons just a little bit bigger than the text they encompass. Even if your ellipses are not placed exactly, the layer capabilities of Photoshop mean that you can move the text or the balloons around to your satisfaction at a later stage.

5 Using the Brush Tool or Pencil Tool, add tails to the balloons. Ensure that the tail points towards the character who is speaking. Finish the tail a little distance away from their head.

Select the balloons and tails on your balloon layer using the Magic Wand. Then go to Select > Modify > Border. In the pop-up window, select how thick you wish the border of the

Tip: You can also squash more text into less space by attaching balloons to the top of panels, so that your ellipse is cut off to some degree, forming a large, straight edge at the panel border. Arrange your text with a long first line, slightly shorter second line, shorter again third line, and so on.

balloons to be (along with font size, this will change depending on the size and resolution of your page). Two to four pixels should be enough. Click OK to create a two to four pixel selection.

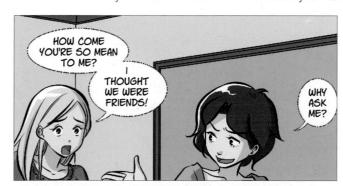

7 Choose the Paint Bucket Tool (with Tolerance set to 255, 'Contiguous' and 'All Layers' unchecked) and use black to fill the current selection, creating black borders.

8 The final stage is to troubleshoot your balloons. If some words are still too long for their position, you can make them narrower using the Character Palette (<-T->).

SFX lettering

SFX (sound effects) is a special, individualistic type of lettering that communicates an impression of sound. SFX are lettered directly on to the page, at a generally much larger size than dialogue. The louder the sound, the larger the type. Just as the

onomatopaeic content of the SFX reflects the noise the sound makes, so the font should try to replicate the sound in visual form – from jagged type for explosions to soft and sinuous replications of running water.

Creating sound effects

Manga artists have created thousands of SFX words across the years, some relatively common and some unique to individual artists. Rarely, however, is the same SFX word deployed in the same way: each appearance will look different, or be incorporated into the art in a new and exciting way. Don't feel limited by existing SFX: try to create your own onomatopaeic words. The current trend is away from literal words like 'BEEP' and 'CRASH' and towards more abstract coinages like 'CZZZTT' (live electrical cable) and 'FWUTHOOOOM' (an explosion). Experiment: if the sound reads right to you on the page, it works.

Your choice of font, and its size, is very important. A small 'BEEP' in an electrical font is appropriate for a mobile phone, while an enormous 'BANG' should feature letters of suitable girth. Don't forget to 'scuff up' your lettering to make it look more natural and less digitally perfect.

CRASH! POW! CRASH!

Infinite variety A

While there are timeless 'classics' among the SFX canon, from 'CRASH' to 'POW', every new sound effect is an opportunity to generate a new sound-alike, or to visually interpret an old cliché in a new and exciting manner.

Deafening impact ▼

The armoured robot collides with the ground with a resounding 'BANG' of mangled metal and compressed earth.

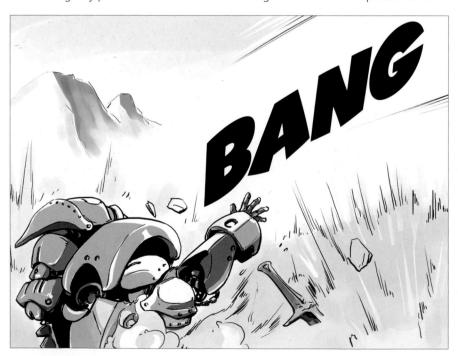

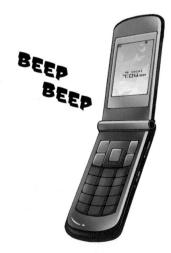

Incoming call A

'BEEP BEEP' can represent an actual generic ringtone; it also lets the reader interpret it as any tone they know.

Tip: Switch things up by scanning in a hand-drawn sound effect, manipulating its colours and angles in Photoshop and compositing it into your digital page.

Practice exercise: Adding SFX to a panel

Just as with lettering balloons, adding SFX to a finished manga panel is a relatively straightforward process. The example here transforms an 'off-thepeg' font to create its special effect, but you could achieve even more impressive results with a freehand rendering of your SFX, either direct to the screen with a tablet pen, or by scanning in hand-drawn lettering and digitally manipulating it.

1 Open your chosen image. Choose the Text Tool and open the Character Palette. Click the image with the tool to create a new 'Text' layer.

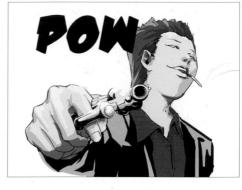

2 Select your font ('Damn Noisy Kids' in this instance) and choose a suitably big size. It doesn't really matter where you place the effect at this stage, as you will move it later. Type your lettering.

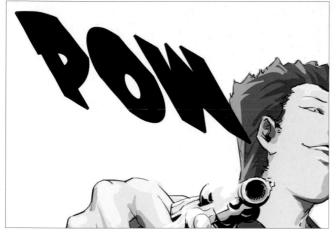

 $3^{\rm Press}$ [Ctrl]+T to Free Transform the text, making it less 'factory fresh' and more visually interesting. Here the letters are tilted to show the trajectory of the fired bullet.

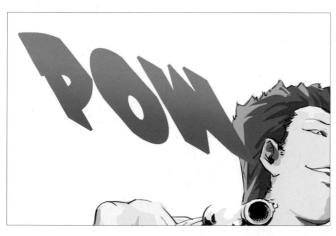

Rasterize the text, then select it with the Magic Wand Tool (with Contiguous off). Use the Paint Bucket Tool or the Gradient Tool to fill the selected area with the colour or colours of your choice. Here, the image has been filled with a subtle gradient of orange to red.

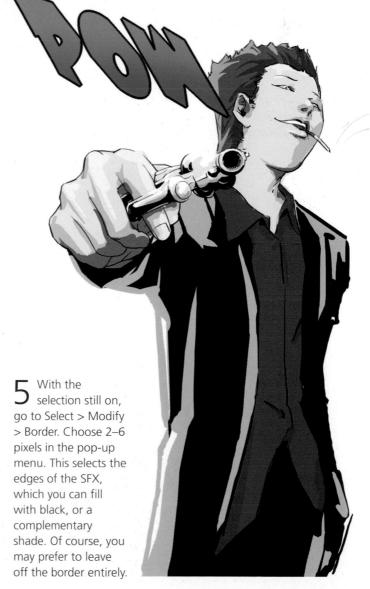

Using filters

You have already used a small selection of Photoshop filters as earlier in the chapter to create speedlines and focus lines. However, we have yet to explain what exactly a Photoshop filter is. Photoshop, as the name suggests, developed out of a digital photography toolkit: a way to improve and digitally alter photos. That it doubles as a superb pure-graphics package is an added bonus. In photography, filters are placed over camera lenses to alter how a picture looks, once taken, from adding burnt umber to skies to adding a soft-focus sheen to a portrait shoot. Photoshop filters do much the same thing but with a much greater variety of filters and the capability of applying these filters to everything from photographs to illustrations long after they have been imported or drawn. Photoshop comes with some filters built in already. If you find them useful, or want to pursue a particular effect they can be helpful. For further filters investigate on the web where there are thousands of freeware and commercial filters available but a great many of them may not be useful to you at all.

Photoshop filters

For manga, the native filters in Photoshop are more than enough for most users to choose from. Some do little more than make your drawings look weird; others, when applied to the right picture, can create amazing effects you could never produce on your own. Have fun experimenting and combining multiple filters.

Original picture A

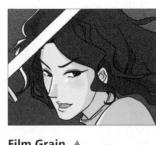

Film Grain A

Diffused Light A

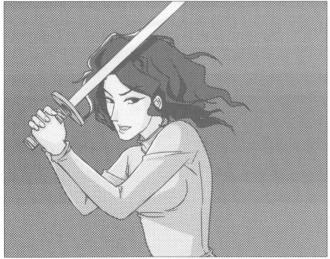

Halftone Pattern

Ocean Ripples A

Graphic Pen A

Glowing Edges A

Extrude A

Practice exercise: Using the Liquify filter

The Liquify filter is guite similar to the Smudge Tool, but the advantage of the Liquify filter is that it is far more accurate and can transform your images without losing any sharpness or detail. Here, the expression of the sad girl in this image can be transformed by the magic of the Liquify filter into a happy face.

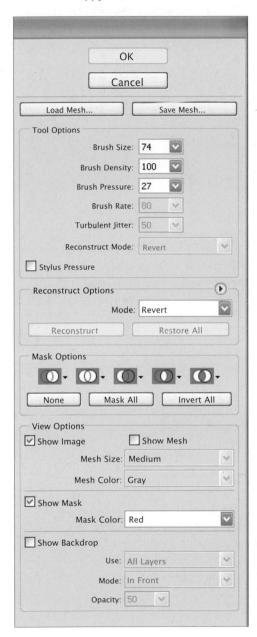

The Liquify toolbar

The main elements to concern yourself with are the Brush Size and Brush Density dropdown menus, and the toolbar along the left-hand side of the Liquify window.

Tip: Liquify is most useful when applied to black and white line work, but it can also be used on finished colour pieces and photographs. There may be more visible blur and distortion in these instances. so it is best to apply your changes before colouring.

Start with an image of a sad girl. Go to Filter > Liquify and a new, separate window will pop up, allowing you to apply the filter manually.

Using the finger tool in the top left corner, choose a large brush size. Click to touch the left eyebrow of the girl, and you will see the lines 'pushed away' by the cursor. Keep pushing until you are happy. Use the reconstruction tool, second at the top left, to undo any mistakes.

Move to the right eyebrow. There is hair at the end of the line that should remain untouched. To protect it, press F to activate the Freeze Mask tool. Carefully paint the area you don't want to Liquify: this will turn red. Now you can safely change the right eyebrow.

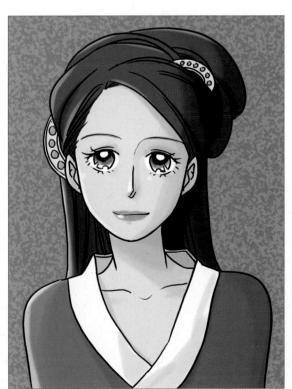

Using the same mixture of tools as before, lift the corners of the mouth upwards to make the sad girl smile, and then click OK. You will be left with your amended image in the standard Photoshop window.

> Tip: The act of Liquifying a line tends to thin it. so be prepared for subsequent touch-up work on thick-lined images. Go slowly and gently with fragile line work so that the lines remain uncompressed.

Inked background project

For most of us, designing and drawing original manga characters is difficult enough. Drawing detailed backgrounds in perspective can be a real headache. But don't worry: thanks to Photoshop and digital inking, there is an easy way to produce backgrounds as perfect as those from professional manga artists. As long as you have a suitable photo for the background you want to draw into your panel, all you need is time and a little patience. You learned how to ink digitally earlier in the chapter. This project applies those same skills to ink directly over a photo. You cannot always rely on tracing photos for backgrounds, of course, especially for fantasy stories, but tracing and inking will give you a good grounding in perspective, line weight and appropriate levels of detail.

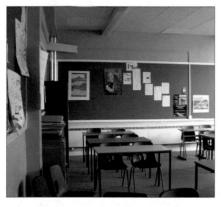

If you took your reference photo with a digital camera, then just open it in Photoshop. If you took it with a traditional camera, you will need to develop the photo first and scan it in. The photo above is of a typical classroom, and will form the reference for this project. Create a new, RGB Photoshop document of at least 300 dpi and drag the classroom photo into it. If the photo appears small on the new canvas, scale it up using Transform.

Tip: Creating your backgrounds on a separate document, rather than tracing them directly into your manga pages, allows you to reuse them in the future.

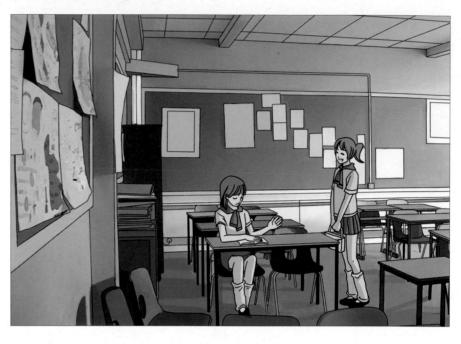

Photographic colour/Digital line art fusion A

The image above shows another time- and labour-saving shortcut. Once the line art has been finished, a blurring filter is passed over the photograph and the colours are tweaked in line with the rest of the manga, then the layers are flattened. This saves time that would have been spent colouring the background, allowing the artist to spend that time on the characters instead. Note how the posters at the back have been changed to white to make the image more coherent.

2 Create a new 'Normal' layer above the photo. Fill it with white using the Paint Bucket Tool and turn the Layer Fill Opacity setting to 50%. This lightens the photo making it easier to pick out details and see existing lines when inking.

3 Create another new 'Normal' layer on top of the other two and call it 'Line art'. This is where the inking takes place. Pick the Pencil Tool and set the foreground colour to black.

A Start inking by tracing the edges of objects. To draw straight lines, first ensure the 'Shape Dynamic' option is turned off in the Brushes Palette.

Then, when drawing the line, hold down [Shift], click the start point, then click the end point. A line will be drawn between the two points. Curved lines can either be drawn freehand, or by the method above, clicking between points that are very close together. Use the Eraser Tool to clean up mistakes.

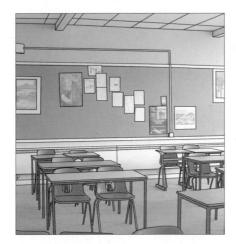

5 Ink all the main edges. Be patient, and take your time with the details. If parts of the picture remain obscure, increase the layer fill opacity percentage on the white layer to throw the darker lines into greater relief.

After you have traced all of the main edges, fill in any areas of solid black on the 'Line art' layer using the Paint Bucket Tool. Use the original photo to guide your placement of these shadowed areas.

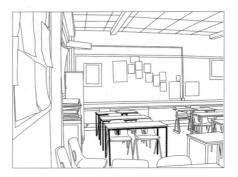

When finished, delete the two layers beneath the 'Line art' layer. The image is now ready for colouring, combining with your characters, and integration into a panel or page.

Tip: It's always a good idea to bear copyright in mind when tracing from photographs. Ideally, you will have taken the photos you use for reference yourself, but if this isn't practical, then do your best to disguise the origins of your chosen image, either by combining elements of two or more different pictures, or adding in elements from your imagination. Furthermore, be sure to colour such digitally inked photos yourself, so that the final product is, technically at least, all your own work. Lightboxing, 'swiping' or digital plagiarism is a touchy issue in themanga and comics industries.

Here is a completed version of the image. Simple, cel-shaded characters work surprisingly well in photo-realistic contexts. Remember, too, that with judicious cropping and by changing character poses, you will be able to use this one background across many different panels.

Outside the classroom

Into the wild >

While the natural world provides fewer straight edges and flat surfaces than the classroom scene, what it lacks in easily inked lines it makes up for in endless variety and intriguing organic shapes. The principles behind inking the classroom photo are just as applicable here, but when inking trees and foliage, you may wish to ink just an abstract outline, filling in detail and shading at the colour stage.

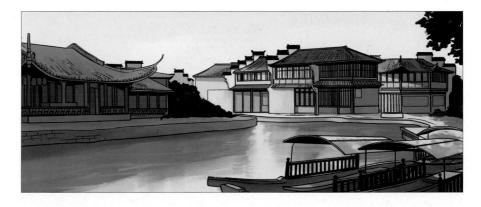

Robot in space project

This project brings together a wide range of the toning techniques you have previously studied, showing how hard-edged and soft-edged brushes can be used to create different textures and patterns of shading, and how an image can be toned using a very limited palette of greys. It also shows how the judicious use of filters (in this case, the 'Add Noise' feature) can spruce up your artwork with simple textures, saving time while also increasing the rewarding complexity of your image. Note, too, the restricted palette used for the flat colours: the first stage of the robot uses only four or five shades of grey. The addition of highlights and shadows increases this, but the initially limited palette holds the image together. Although the example here features the blunt, hard lines of a giant robot, the shading techniques are just as applicable to more fleshy subjects, although their skins will, of course, be far less reflective.

Halftone robot in space ▶ The final image blends together a number of techniques to produce a professional result. Flat greys, metallic highlights and filter-applied textures are all unified by transferring them into halftone patterns.

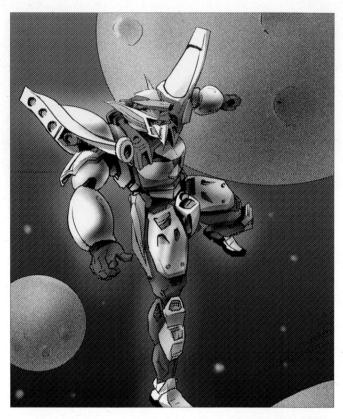

1 Open the line art: here, a giant robot with planets and stars in the background. Separate the line art from the white background as before. Using grey tones, add flat colour on a new 'Flats' layer. If you have difficulty selecting areas with the Magic Wand Tool, use the Pencil Tool to apply greys.

Create a new 'Multiply' layer and call it 'Shading'. Select areas on 'Flats' using the Magic Wand Tool, then brush shading on to the 'Shading' layer. Overpaint your first pass with darker shadows. When finished, duplicate 'Flats' and merge it with 'Shading'. Turn off the original layer.

3 To apply metallic light-reflective effects to curved areas, select the Dodge Tool and set Range to 'Midtones' and Exposure to 10%. Choose a soft brush tip and gradually brighten up any areas facing the light. Here, our light source is positioned at the top left of the image.

On the same layer, switch to the Burn Tool. Set Range to 'Midtones' and Exposure to 8%. Use the tool to create shadows on the areas where little light is being cast. Remember, metal not only reflects the light from the main light source, it will also reflect light bouncing off surfaces nearby. In the close-up example, above, you can see how the arm reflects a little of the light bouncing off the main robot body. If the shiny metallic effect is not strong enough, use Image > Adjustments > Brightness/Contrast to up the distinction between light and dark.

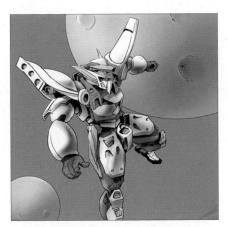

Underneath the 'Flats' layer, make a new 'Background' layer. Use the Paint Bucket Tool to fill in the flat colours. Select the planets and use the Dodge and Burn tools to apply light and shade to the spheres, as well as creating details, such as the shadowed craters, using Burn to pick out highlighted rims.

Tip: Reserve your strongest highlights and shadows for foreground elements, such as the robot shown here. Background elements should never stray too far from neutral mid-tones.

Select the planets and add a new layer, set to 'Soft Light'. Fill the selections on this new layer with a dark grey, then go to Filter > Noise > Add Noise. Give the amount a high value and make the Distribution 'Uniform'. Click OK. The texture of the planet is now more convincing. Merge this layer with 'Background'. Use the Magic Wand to select the space backdrop, and apply a gradation with the Gradient Tool. As the light source strikes your robot from the top left, it makes sense to have your gradient lighter towards the top left of the image as well.

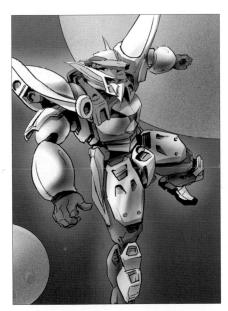

7 On top of the merged 'Background' layer, create a new layer to add some atmosphere. Choose a soft brush with Opacity and Flow set to 20. Paint a white light around the robot to separate it from the background. Using a variety of brush sizes and opacities, draw some stars in the infinite night.

For printing, you need to convert greyscale into black dots. Merge the tone layers into a single layer. Create a new file with the same resolution and size as this image and drag the tone layer into the new file. Ensure it fits. Go to Image > Mode > Bitmap and change this image to a bitmap file, choosing the Halftoning options as before. Next, use Image > Mode > Grayscale to change it back to greyscale. Drag the layer back to your original file and remerge it with the line art.

Fight scene project

Fight scenes form the backbone of many manga adventures. Though the imagery itself is often strong enough to 'sell' the furious interchange of blows, you'll find that the addition of powerful sound effects ups the ante of your combats, making them weightier and more impressive.

To the right is a typical impact, with one fighter punched hard enough to throw him out of the panel. Without SFX, the action is readable enough, but their addition gives focus to the punch's force, punctuating the action for the reader. This project shows how to incorporate SFX into an image.

Brutal beatdown >

The final image shows, with the SFX, the exact point where the puncher's fist connects with his opponent's face, as well as indicating the magnitude of the blow by the size of the typeface.

1 First, select the Text tool, and choose a suitably chunky font in a large, even bolded, typeface. Type in your chosen SFX word for the sound of a connecting punch. Here, we've used 'THWAK', but 'WUNNCH', 'THUDD' or any other word you believe captures the spirit of the action are equally applicable.

Tip: The first font you choose will not always be the best for your chosen sound effect, so keep the Character Palette open as you work, and try a few alternatives before you settle on one. You may want to print out a selection of your favourite SFX fonts for speedy reference.

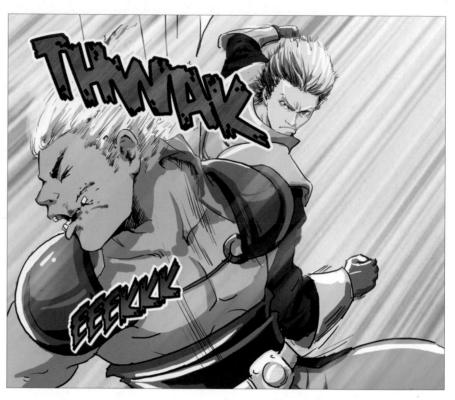

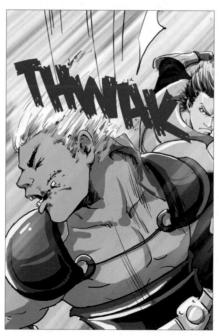

Using [Ctrl]+T to Transform the text, angle your SFX to the direction of the impact. Rasterize the text, then use the Magic Wand to select it. Colour your selection with an appropriate colour or gradient. Don't worry too much about the colour at this stage – you can easily change it later.

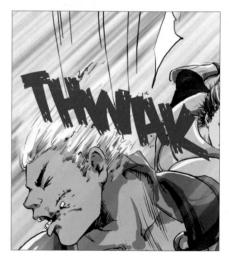

To integrate the SFX with the background action more, you can add some speedlines. With the text still selected, duplicate your SFX layer. On this new layer, go to Filter > Noise > Add Noise and set the noise amount to a high value. Next, go to Filter > Blur > Motion Blur. Set the angle so that it matches the angle of the speedlines in the background, and choose a medium blur radius. Change the layer blend mode of the duplicate layer to 'Linear Light'. It will blend with your red layer.

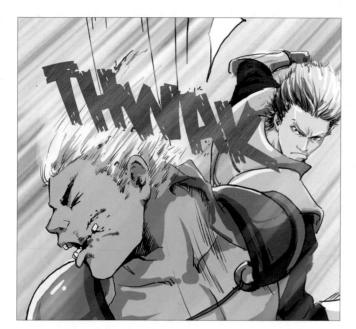

A Merge the duplicated layer with the original one. You can now adjust the colour further by using Image > Adjustments > Hue/Saturation. In order to make the speedlines on the SFX more visible, you can use the Brightness/Contrast settings. If you still feel that your sound effect needs further personalization, you can make it more individual and interesting by attacking it with the Burn or Dodge tools, lightening and darkening various areas.

We have concentrated solely on the 6 SFX point of impact so far, but you can also increase the drama by including a sound effect from the victim. Grunts upon impact may be shown in speech balloons, as SFX, or even as SFX within speech balloons. Typical shouts include 'UNFF!', 'ARRGH!', 'ERGGH!' and so on. This is accomplished in the same way as the punch, but in a smaller font, and with a dimmer colour. This is because the 'THWAK' forms the focus of the panel, with the 'EEEKKK' the secondary and less important element. The image at right shows what happens when you reverse this: the screaming fighter looks like he is hamming up the result of the impact.

Tip: Sound effects, like dialogue, should guide the reader's eye down the page, from top left to bottom right. Remember that size is a great indicator to a reader of importance, as well as amplitude: while an earthquake and an alarm clock may not emit the same decibels, the latter might seem just as loud to a light sleeper.

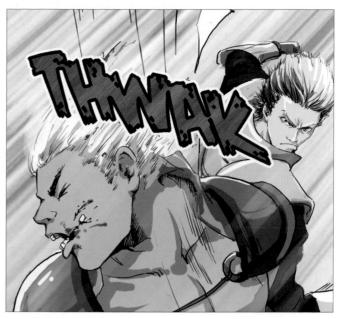

5 Your SFX should still be selected. At this point, you can add a border around your selection. First, go to Select > Modify > Border, setting the value at around 4 or 6, to fill in the selected area with the colour of your choice. Use standard black. Then, with the border selection still on, go to Select > Modify > Expand and put in a value of 8 or so (for this image). Add a new layer underneath the SFX layer and fill the selection with white. Merge this layer with the SFX layer.

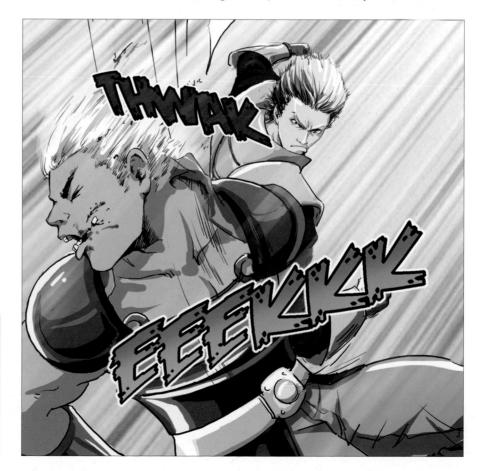

Colouring basics

The basic Photoshop tools used to apply grey tones and shading in the previous chapter are much the same tools you will use to colour your illustrations. However, using colour means that, along with a palette running into millions of

possible colours, you will need to explore the more advanced settings of each of these tools in order to get the best out of them. Knowing the basics of light and shade from your grey toning exercises will stand you in good stead.

Settings

As we have already seen the Hardness, Opacity and Flow settings of the Brush and Eraser tools can be altered in the Options Bar. These settings become stylistically important when applying colour.

Hard edge ▶

A cel-shaded, animation look can be achieved with layered flat colours, a hard-edged brush and 100% Opacity.

Soft edge ▶

A more natural look can be created by blending soft-edged brushstrokes together with colours at 50% Opacity.

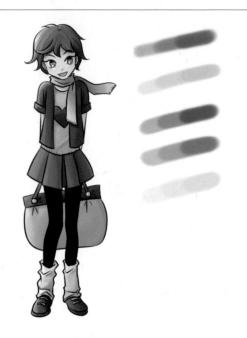

Adjusting colours the easy way

Whether you are first creating colour schemes for your characters and wish to amend them before you roll out a palette across an extended sequence, or you want to tweak your final pages after they have been coloured, you may find some useful tools in the Image > Adjustments menu. The Levels tool has already proved useful for controlling light and dark while inking, but three further options -Color Balance, Brightness/Contrast and Hue/Saturation should be explored.

Original A

Apply Adjustments on a layer separate to (beneath) your line art. If you have enough RAM, use an Adjustment Layer instead, which allows you to re-alter the changes indefinitely.

Color Balance

This makes changes within the highlights, midtones or shadows. Its sliders represent the six colour polarities. Use the Color Balance to adjust the whole atmosphere of a piece.

Brightness/ Contrast ▲

One slider controls brightness, the other contrast. Exaggerate extremes to punch up 'flat' colour on a piece. Brighten dull shades or dampen startling ones.

Hue/Saturation A

Hue is used to change the colour of objects, such as this robe. Saturation makes the colour more intense or muter. Brightness works in much the same way as in Brightness/Contrast.

Colour modes

RGB and CMYK are the colour modes that will be used most often when digitally colouring. RGB is the standard used in televisions and computer monitors. It stands for red, green and blue, the primary colours that can be blended together to create every visible colour. White is the combination of these colours; black, their absence.

CMYK is the standard of print media. It stands for cyan, magenta, yellow and black, the secondary colours on the colour wheel. Printing presses use differing percentages of the three colours, plus black, to produce a wide colour spectrum. In colour theory, the combination of cyan, magenta and yellow produces black; however, on real

presses this tends to result in brown, so black is added as a fourth 'colour'. The vast majority of commercially printed books and magazines are produced on CMYK presses. If you want to release your manga on the web, it is better to use RGB. If you want to print your colour manga professionally in books and magazines, you'll need CMYK.

■ The colour wheels

The primary colours of red, green and blue blend together to produce the whole spectrum of visible colours. The secondary colours produced by a 50/50 blending of two of the primaries are cyan, magenta and yellow. Appropriately, when these colours are used as the starting point, the result of a 50/50 intersection between the CMY colours are the RGB hues, as shown in the second diagram. The RGB spectrum is one of addition, blending to white, the CMY spectrum one of subtraction, blending to black.

RGB versus CMYK

Color Picker

If you are having your manga printed, it is essential to work with colours that definitely exist in the CYMK mode. When the Color Picker is open, press [Ctrl]+[Shift]+Y. This changes the colours that are not available in CMYK mode to grey, while the ones that are printable appear as usual. Pick your colours from the 'safe' area. Use the same command to return the Color Picker to normal.

If creating artwork for print, you may think it best to work in CMYK mode to save the trouble of converting, and ensure that you only use the colours on screen that will show up in print. However, CMYK files take up 25% more space on your hard drive than their RGB equivalents, and many Photoshop filters will only work in RGB mode. For those with lower-specification computers, it is best to work in RGB and convert to CMYK just before sending the file to the printer. Don't flip between RGB and CMYK mode while working, as each switch loses a little clarity in the image. If you want to see your RGB image in CMYK without having to convert it. select View > Proof Colors.

As computer screens use RGB and printers use CMYK, the image on your monitor will not be exactly the same as the one printed on paper. Some RGB colours don't exist in CMYK, particularly the yellow/greens and bright reds. This isn't a problem when publishing online, but may cause changes when outputting to CMYK for paper publication.

Colouring techniques

Colouring a manga page is more complicated than toning it, although the principles are much the same. For most, the experience and results of colouring are more satisfying. Using colour is more forgiving than grayscale on one level, as

the more expansive palette allows you to use different hues that share similar luminosities – different shades of the same grey on a non-colour image. This spread shows how to set up a line art image for every colouring style.

Practice exercise: Applying flat colours

Flat colours are the basic colours you add to your initial line art to divide areas from one another to make more advanced colouring easier and quicker down the line. Although it is not necessary to choose the same colours you will be using in your final image - many colourists use near-random, conflicting hues just to guickly subdivide characters from backgrounds and skintones from clothes, leaving colour decisions for later - it often helps to use colours close to those you will be using later, to get an idea of your page's colour composition. The most important function of the flat colour layer is that it allows you to easily select areas with the Magic Wand Tool without worrying about the line work. You can select individual areas (with 'Contiguous' checked) or all areas sharing the same colour (unchecked), which can shave hours off the time it would otherwise take to complete it.

Tip: If you are using non-bitmapped line art (art you have scanned in grayscale and altered with the Levels function), you need to be careful when selecting an area to expand your selection so that it goes fully underneath the lines. Otherwise, a white edge may be left between the lines and colour. In most cases, it should be enough to increase the tolerance on the Magic Wand Tool, but be aware of high-detail areas or tight spots on your illustration.

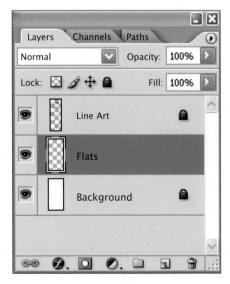

1 Open your line art and set it to RGB mode (Image > Mode > RGB). If you have separated your line art from the white background, create a new 'Normal' layer called 'Flats' between the background and line art layers. If the line art and white background are on the same layer, duplicate it, set the mode to 'Multiply', then create a new 'Normal' layer called 'Flats' in between the two identical layers.

If your lines do not perfectly join up, create a new layer and use a 1-pixel black Pencil Tool to seal them. If you prefer 'gappy' line work, you can delete this layer after completing the flats.

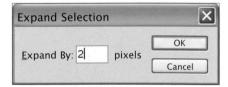

On the 'Flats' layer, use the Magic Wand Tool to highlight and select areas to colour. For non-bitmapped line work (some grey in the lines), select a Tolerance of 50. Check 'Contiguous' and 'Sample All Layers' and leave 'Antialias' unchecked. Press down [Shift] to select multiple areas, or [Alt] to unselect areas. Next, choose Select > Modify > Expand, set the value to 1 or 2 and click OK.

On the 'Flats' layer, use the Paint Bucket Tool (with 'Anti-alias', 'Contiguous' and 'All Layers' unchecked) to block in the desired colour for the selected area. Alternatively, place the colour you want as the Background Color in the palette and press [Delete]. Use [Ctrl]+D to deselect the area.

5 Some parts of the image may be missed by the Magic Wand Tool and will not be coloured. Use the Pencil Tool to fill these areas. The Pencil Tool is used to ensure the colour has a sharp edge, for easier future selection. For the same reason, if you use the Eraser Tool, ensure the mode is set to 'Pencil'.

Repeat the above steps to fill in all of the flat colours. If you created one, delete the layer you used to seal the black lines. If you wish to adjust the colours to make them more complementary to one another, use the Magic Wand Tool, with 'Contiguous' and 'Sample All Layers' unchecked, to select all areas of green on the 'Flats' layer, for example. Next, use Image > Adjustment > Hue/Saturation or Color Balance to adjust until you are happy.

Colouring styles

There are two main styles of colouring. The first is called 'Cel Shading', which is similar to the colour schemes seen in cartoons and anime, while the other is 'Soft Shading', which provides a more natural look with greater gradations between colours. Both modes begin with the flattening process.

Cel shading A

Uses pure, unblended colours; sharp distinctions between bold highlights and strong shadows. While it requires no less skill, the limited palette can prove quicker to implement.

Soft shading A

A more natural, painterly style, blending a range of colours in each area, from light to dark, while paying greater attention to light reflection and the layering of shadows.

Practice exercise: Cel shading (shadows)

Cel shading is the most basic and common way to colour manga. Drawn from animation cels, where budget and time constraints rewarded bold, hardedged shadows, cel shading is now a

Normal Opacity: 100% >
Lock: Fill: 100% >

Line Art

Shading

Background

Background

first, lock your 'Flats' and 'Line Art' layers, and create a new layer, set to 'Multiply', on top of your 'Flats' layer. Call it 'Shading'. This is where you will apply your shades as grey tones.

Here is the image with the 'Flats' layer hidden. Emphasize the depth of your shadows with a darker grey, painted over the first. Turn the 'Flats' layer on and off periodically in order to check your progress. Use an Eraser Tool at 100% Flow and Opacity to correct any mistakes.

popular style in its own right. In real life, the complexity of lighting means that objects rarely cast a lone, clear shadow, but manga can simplify and exaggerate colour, shadows and highlights just as it

2 Use the Magic Wand on the 'Flats' layer to select the area you want to colour, with the Tolerance set to 0 and 'Contiguous' and 'Sample All Layers' unchecked. Here, the hair is selected. Now switch to the 'Shading' layer. Pick a grey shade from the Color Picker and select the Paint Brush. You can always adjust the grey with Color Balance at a later stage.

5 Use the same method to add shadows to the other parts of the image. Once you have finished, you can use Color Balance to adjust the shading, or leave them as simple grey.

Tip: If you have used a limited palette on your image, you will find that using the Magic Wand Tool with 'Contiguous' unchecked will select all like-coloured areas (here, the hair and the eyes). Use the Lasso Tool and the [Alt] key to deselect unwanted areas.

simplifies the characters themselves. This exercise shows you an easy method of adding cel-shaded shadows to your flats while leaving the original colours intact.

Choose a hard-edged brush with Opacity and Flow both set to 100%. Select your light source (here, the top left again) and paint the areas not facing it with the grey. Remember to keep your light source consistent.

Practice exercise: Cel shading (highlights)

Highlights are just as important as shadows when colouring in a cel shaded style, and they are created in much the same fashion as shadows – on a separate layer. This time, however, the highlights are painted in using brightened shades of the colour of the material in question. This exercise shows you how to get the most out of your highlights. As before, we start with our character's hair.

Tip: Remember that not all materials reflect and refract light in the same way. Hair, eyes and metals are usually the most reflective elements of a character, with skin, leather and so on coming a near second. Fabrics and matt objects absorb light, so dresses, wool coats, jeans and the like should not have highlights applied to them as shinier textured elements.

2 Use the Magic Wand Tool to select the hair, then go to the 'Highlights' layer. Paint areas facing the light source with the colour selected in Step 1. Keep the light source consistent.

Tip: Adding some softedged shading to your cel art is an easy way to humanize your characters and stop them looking too much like dolls.

1 Create a new 'Normal' layer called 'Highlights' between the 'Flats' and 'Shading' layers. Select the Brush Tool and double-click on the Color Picker to bring up the colour selection window. Use the Eyedropper Tool to sample the

When this is done, add an extra, white highlight on the shiniest areas. Keep this effect subtle, limiting it to a few areas, ensuring the shine is consistent with the type of object.

hair colour from your image. A small circle indicates that colour on the colour spectrum. Move the sensor up and to the left a bit (above) to pick a colour lighter than the current shade of hair, but within the same colour family.

Continue to add appropriate highlights to the other parts of the image. In this example, highlights have been applied to the headband, leg and sock, shoes and dress.

Practice exercise: Soft shading

Soft shading produces a finished look that is closer to natural media than cel shading. It replicates the spirit, if not the exact materials, of a freehand painting, as opposed to the pixel-perfect, highlight-midtone-shadow images produced by the method outlined on the previous spread. Soft shading grants

you the intricacy and layering of colour in a traditional painting alongside the accuracy, flexibility and, best of all, the multiple levels of Undo found in your graphics software. As the name suggests, soft shading is built up out of gentle brushstrokes, using multiple shades of the same colour and

overpainting of areas in order to increase the depth of shadows or the brightness of highlights. As a result, it requires more skill and patience than cel shading. This exercise will teach you the basics of applying soft shading to an already flattened image, and the way to blend colours together.

1 We begin with an already flattened image. Duplicate the 'Flats' layer and name it 'Colour'. Set its mode to 'Normal', making sure the 'Colour' layer is above the 'Flats' layer. Keep the 'Flats' layer, as it will make Magic Wand Tool selections easier if you later decide to reselect areas you have already softshaded ('flat' areas are simpler to select than those that mix a number of similar colours, especially if using soft brushes).

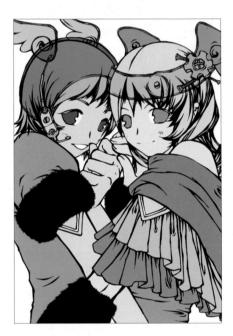

This time, we will start our shading with the shawl, as its folds make colouring interesting. At this point, the colours on the 'Colour' layer are still untouched, so it's fine to use the Magic Wand Tool to select the shawl directly on this layer. Leave 'Contiguous' and 'Sample All Layers' unchecked.

Choose a soft-edged brush and pick a colour a few shades darker than the flat shawl colour. Set Opacity and Flow to 40%. Increase the brush size with [Shift]+] ([Shift]+[decreases the size) until you get a big brush (or right-click and drag the slider). Paint shadowed areas.

As with cel shading, the next step is to pick an even darker colour for the darkest areas of the shawl and paint these with a smaller brush. Having the Opacity and Flow at 40% allows you to build up colour gradually. Paint plenty of strokes in the places where the shadows are darkest. If you make a mistake, don't use the Eraser because this will reveal the layer underneath. Use the Paint Brush to paint over the mistake - or the Undo function, of course.

Tip: Remember again that fabric, skin and metal all reflect light in different ways, so you may find some elements of your image need less rendering than others. Conversely, the brightest, shiniest elements (for example, eyes and hair) may need additional layers of highlights to be added, or even the use of brushes at a higher Opacity and Flow.

5 Now pick a colour a few shades lighter than the original shawl midtone, and paint those areas or folds facing the light source.

Tip: If you change your mind about a particular colour area, you can switch to the 'Flats' layer, use the Magic Wand Tool to select a whole section, then flip back to the 'Colours' layer, using the Hue/Saturation sliders to alter the colours to your satisfaction.

The lighter and darker colours of the shawl have now been implemented, but the transitions between them aren't very smooth, and some of the folds are lacking detail. To build up the transitions, you will need to select colours inbetween the existing ones and blend using a smaller brush. Many of the in-between colours may already exist in the image at the edges of your brushstrokes, so use the [Alt] button and Brush to grab them with the Eyedropper Tool. Patience is the key: you may need to paint certain areas over and over again to create a convincing effect.

7 Use the same methods to colour the rest of the picture. Remember to zoom out periodically to check that you aren't over-working some smaller elements to the detriment of the whole: knowing when to stop colouring is often the hardest part of the soft-shading process.

Colouring a page

The two methods you have learned to colour characters are flexible, and can even be intermingled within a panel or page. Colouring a full panel follows exactly the same steps, but the number of characters may be higher, and there will usually be background elements to think about at the same time. Colouring an entire page takes a few more steps, and requires

a little more thought. The first thing you should consider is how to make your pages cohesive and coherent, rather than a rag-tag collection of disparate panels. Think about limited colour palettes and background colours, and how a single dominant colour on each page can influence atmosphere and mood, as well as indicate scene changes.

Practice exercise: Mixing shading techniques

Using Photoshop allows you to be very flexible with the methods you use to colour each page, mixing and matching the techniques you know so that they fit the content, rather than being beholden to one style or another. The examples

below are mostly cel shaded, with soft-shaded details on the characters and gradients to add depth and texture to the single-colour backdrops. This exercise allows you to put what you've learned into action.

Tip: The background of each panel sets the atmosphere for the page. Using similar tones across panels maintains integrity: though an out-of-place flash of a conflicting colour can create surprise.

1 Open your line art in Photoshop and clean the page. Separate the lines from the white background if they are not yet on an individual layer. Lock your 'Background' and 'Line Art' layers so that you won't mistakenly draw on them.

2 Create a new layer between 'Background' and 'Line Art' called 'Panels'. Fill a background colour for each panel. By using a different colour for each one, you'll be able to use the Magic Wand Tool to select the whole panel later. The colours here represent natural daylight. Each panel is selected with the Polygonal Lasso Tool (use the Magic Wand Tool and [Alt] on 'Line Art' to delete overspill). Fill using the Paint Bucket Tool.

3 Create a new 'Flats' layer on top of 'Panels'. Colour in the flats using the Paint Bucket and Pencil tools, as in previous exercises.

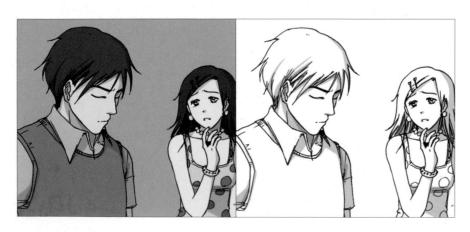

On top of the 'Flats' layer, create a new 'Multiply' layer called 'Shadows'. Use a hard-edged brush at maximum Opacity to shade in areas of darkness using a grey colour. Return with a darker grey colour to areas of deeper shadow. These shadows use the cel shading method. Remember, if you want to get a clearer view of the shadows you are painting at any point, switch off the 'Flats' and 'Panels' layers to view the shadows against a white background.

On top of the 'Shadows' layer, create a new 'Normal' layer called 'Highlights'. Here, the highlights are applied as soft shading. Use a softedged brush in a lighter version of the appropriate colour, with Opacity set to 40%, to paint over areas facing the light source. Overpaint several times to create the brightest highlights.

If you want to adjust the colours or atmosphere of an entire panel, use the 'Panels' layer to select a panel with the Magic Wand, and adjust from there. As an example, the bottom-right panel above has been desaturated to make it more dramatic. The panel is selected in the 'Panels' layer; the adjustment are made on the 'Colour' layer using Hue/Saturation.

6 Create a new layer on top named 'Detail'. Here, you will colour the elements you haven't added detail to

yet, such as the eyes, hair clips and rosiness in the cheeks. Be flexible in your Brush settings: you may wish to use a soft, low-Opacity brush for the cheeks, and a hard-edged brush for the hair clip. Pay attention to the reflections in the eyes.

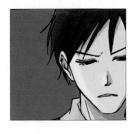

'Highlights' and 'Detail' layers, renaming the merged layer 'Colour'. If you want to make adjustments to any areas of colour, you can now select areas on the 'Flats' layer and make changes on the 'Colour' layer using the tools in Image > Adjustments.

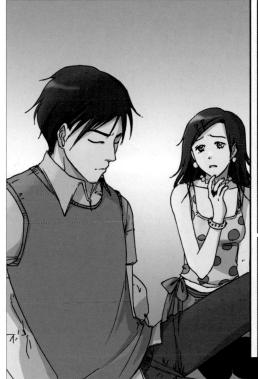

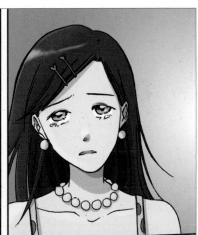

You may want to add some gradients to the flat background colours in order to enrich them. Create a new 'Gradients' layer above the 'Panels' layer, and select the panel you want in 'Panels'. On the 'Gradients' layer, with the appropriate panel selected, choose the Gradient Tool. Set the foreground colour to the current background of the panel using the Eyedropper Tool, set the background colour to a dark shade of the same colour, select the kind of gradient you want to use and drag the Gradient Tool across the panel. The gradient will be created. The three panels above use Radial gradients.

Tip: If you decide that you want to add in fully rendered backgrounds or Photoshop-altered photographs after you have already coloured your page, remember that you can copy them in on a new layer underneath the colours of your characters. You can even place them beneath a semi-transparent Gradient layer if you still wish to communicate the atmosphere of each panel in this way. A page isn't finished until you are satisfied with it, so experiment with every new technique you learn to develop your style.

Night image project

Over the previous few pages, you have learned how to colour an image in two different styles, and how to compose and coordinate panels in order to create a pleasing and atmospheric page. With these techniques, you should be able to cope with any of the colouring projects you may encounter in your manga career.

However, one of the more difficult scenes for a colourist who is just starting out is one set at night. Everything changes colour in the darkness, not only becoming paler, bluer and more desaturated, but also being influenced and transformed in shade by the light sources acting upon them. Moonlight transmutes reds to purples, fades flesh to bone-white and strips warmth away. Neon tones its subjects in sickly greens, pinks and yellows. Streetlights cast unnatural 'fires' across those that walk beneath them. In short, at night everything you know about colour changes. This project will give you an excellent grounding in working by moonlight, with an image of a partygoer stepping out for some air.

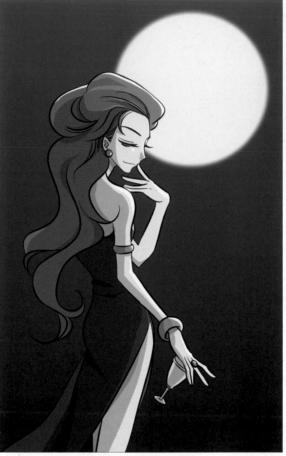

Met by moonlight This image shows a very simple technique for creating nocturnal images: a carefully chosen, blue-tinged palette to begin with, followed by shading as usual and, as a final step, a wash of colour over the whole image to further transmute the shades. Try using the same wash technique with yellows or reds to add atmosphere to daytime scenes. Where this image is concerned, as a final step, you may wish to develop the background with a gradient effect (on the 'Blue' layer) and tighten the palette yet further by compressing the colour layers and using the tools in Image > Adjustment.

1 First, open your 'Line Art' layer and prepare it for colouring by cleaning up the lines and separating the line work from the white background.

2 Create a new layer named 'Blue' beneath the 'Line Art' layer, and fill it with a dark blue colour. This will form the background for your night scene.

Create another layer on top of the 'Blue' layer and name it 'Moon'.

Pick a large, soft round brush, and use a pale yellow to draw the moon.

4 Fill in the flat colours of the character on another new layer, above 'Moon', using the techniques you have already learned.

5 On a new 'Multiply' layer named 'Shadows', draw shading with a purple-grey colour. Turn off the other layers to get a better view (right).

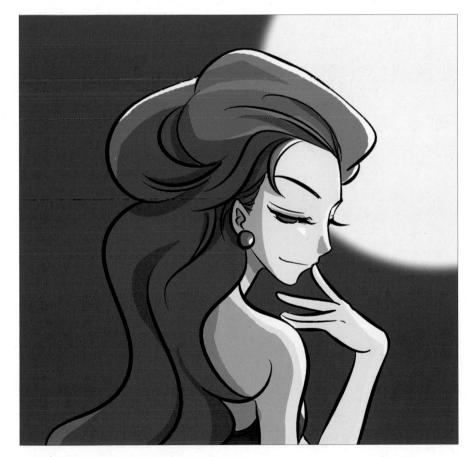

 $\label{eq:continuous} 6 \text{ Create a new 'Normal' layer called 'Pale Highlights' and paint some of the lighter areas facing the moonlight. On the extreme edges facing the moon, add some of the pale yellow colour to the hair, skin and dress, reflecting some of the full moon's bright light back to the source.}$

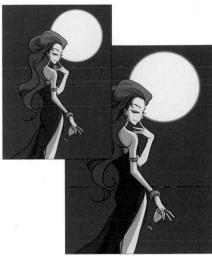

Create a new layer on top of the other colour layers, naming it 'Blueish'. Set this layer's mode to 'Color'. Now go to the 'Flats' layer, and select the entire character with the Magic Wand Tool, using the [Shift] key to select multiple areas. When the whole character is selected, go back to 'Blueish' and fill your selection with the blue from your background. The character's colour changes to blue. Don't panic: change the Layer Fill Opacity to about 40% (on the Layers Palette) and your character's colours will show through.

Photoshop is an incredibly versatile graphics package, filled with possibilities for you and your manga creations.

The more you create or colour your manga digitally, the more useful you will find Photoshop and the greater the number of options, techniques and effects you will discover.

This chapter will introduce you to a selection of them.

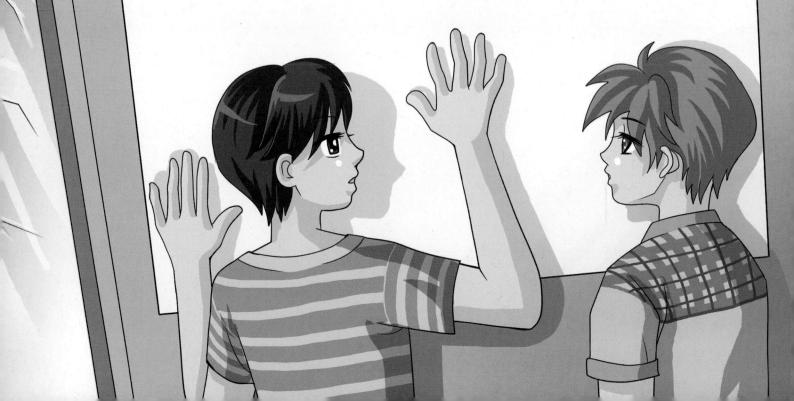

Customizing colour palettes

Sometimes, choosing colour schemes can be exceptionally difficult: it can be easy to stay with what you know and are comfortable with, and hard to stray out of the 'blue for sky, green for grass' mindset. That's why 'borrowing' the colour palettes of images that creatively inspire you can be a useful shortcut. The process is simple: find an image the colours of

which you admire and think are appropriate for your own uncoloured piece, import the picture into Photoshop, and convert the image into a custom colour palette, which you can then use to digitally paint your own creation. This exercise will show you how to convert a scanned or downloaded picture into just such a customized palette.

Practice exercise: Converting an image to your Color Palette

1 First, find a colour image that you like from a book, photograph, manga or the Internet. Scan it in or save it to your computer, and open the image in Photoshop.

Now, convert the image to Indexed Color mode by going to Image > Mode > Indexed Color. Indexed Color specifies a limited, 'indexed' palette for your file, rather than the millions of colours that are available to you in RGB or CMYK modes. Go to 'Color' and enter the number of colours that you want to extract from the image. A good number is in the range from 150 to 250: you want enough colours to be able to accurately capture any blends or gradients, but not so many that any shades you want specifically get lost among thousands.

To view the colour palette you've created based on this image, go to Image > Mode > Color Table. If you want to add more colours to the palette, click the last empty slot and pick the colour up using the Eyedropper Tool in this options window. Click 'Save' to save the colour palette as a *.act file and OK to exit. Remember where you save the file so that you can load the palette later.

Tip: Choose a memorable filename for the palette, not just 'Palette 1'. Name it after the colour range it contains ('Deep Reds') or the image you pulled the palette from.

Tip: The tighter and more limited your colour palette (i.e., the fewer colours you choose to import), the more useful it will prove to you, as you can create shades and highlights yourself from imported median tones. For the same reason, you will get better results from illustrations with limited palettes than from more naturalistic photographs.

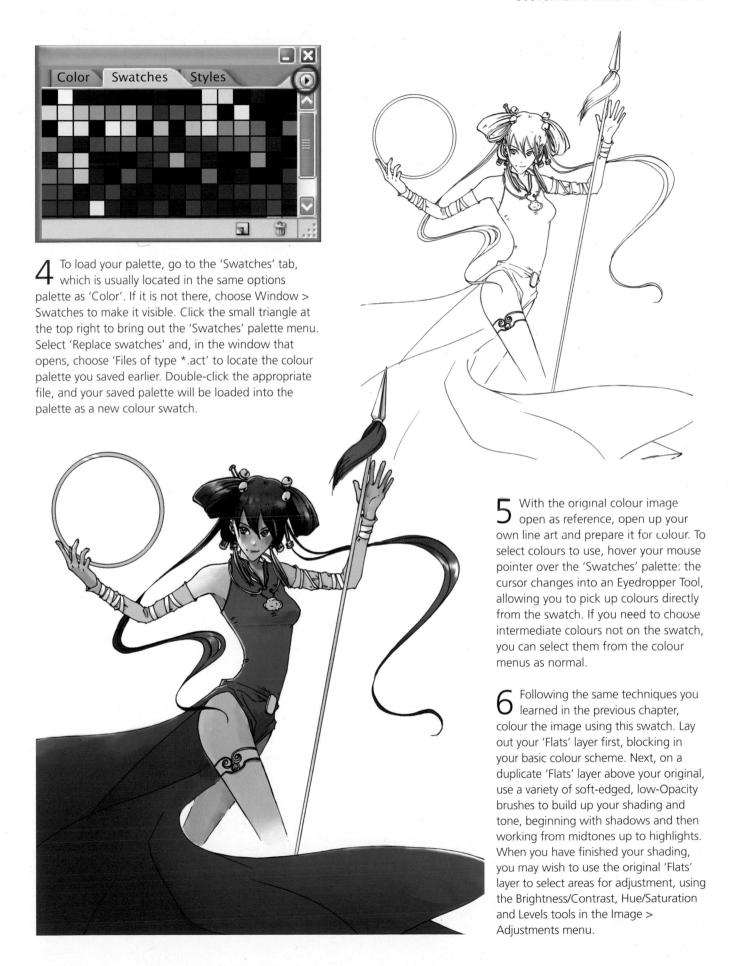

Creating motion

In previous chapters, you have learned how to represent extremes of movement using black and white speedlines and focus lines. However, these options can often cause a colour page to look cramped or over-rendered by the sheer amount of line work, limiting their efficiency at replicating speed. While the simplest option is to 'knock back' these black lines

to a lighter colour, there are a number of more advanced techniques using blurs, smudging and changes of focus that create more cinematic effects in glorious colour. The following pages will walk you through some of the options available, many of which will suit some styles of panel or forms of motion better than others.

Practice exercise: Motion in colour 1

This method is the equivalent of drawing black and white speedlines. Rather than just drawing different kinds of lines, we can create a similar effect, better suited to colour, using the Motion Blur filter and the Smudge Tool.

1 Open a colour image in Photoshop. Merge your line art and character colour (leave the background). Save as a new .psd file. Duplicate the character layer, place it behind the original and set its mode to 'Normal'.

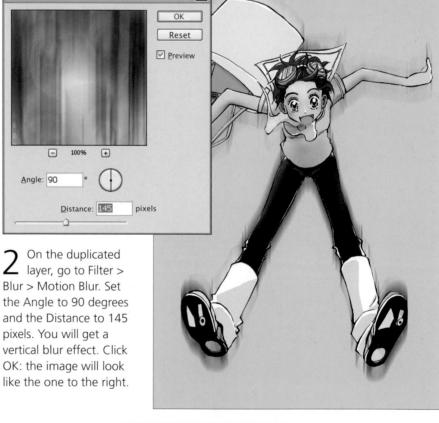

To make the girl look as if she is jumping down, you need to move the blurred image up a little bit. Use the Move Tool (V) to move the duplicated layer upwards until the motion effect comes from the upper side of the character only.

Motion Blur

To further sell the 4 motion effect, you will need to alter the original character work. Work on the original character layer (duplicate it as 'insurance' if necessary). Select the Smudge Tool, with a small, high-strength Brush. Smudge the upper edges of the character in the direction of movement. Subtlety is key here: a few smudges are enough.

Practice exercise: Motion in colour 2

This example introduces you to the colour equivalent of focus lines, perfect for images containing one- or two-point perspectives. This is a one-point perspective shot of a character running towards the reader. The background will blur in a radial point around him, focusing the reader's attention.

1 Open the colour image in Photoshop. Keep the background and character on separate layers.

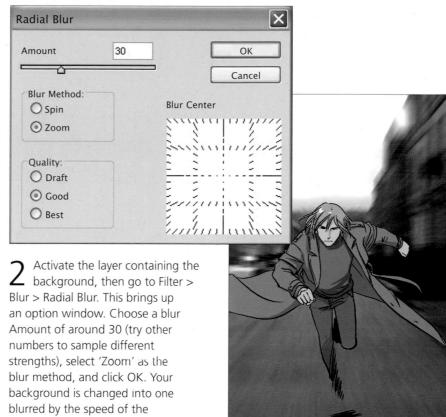

Now you need to add the same speed effect on the character's layer. However, you do not want the whole character to be blurred, as this will obscure the face and your line work and detract from the focal point of the image. To avoid this, you need to enter the Quick Mask mode to 'mask' the areas you don't want to apply the filter to. To do this, click the Quick Mask button below the Color Picker on the

toolbox (or press Q). Use a black brush to paint over the areas you want to leave unaffected. The areas you paint over turn red, but don't worry, you are not applying paint to the image itself. If you make a mistake, use a white brush to correct it. Once you have finished painting over the relevant areas (in this case, those at the very centre of the image), click the small icon next to the 'Enter Quick Mask' icon, and everything but the areas painted in red will be converted into a selection.

focal character.

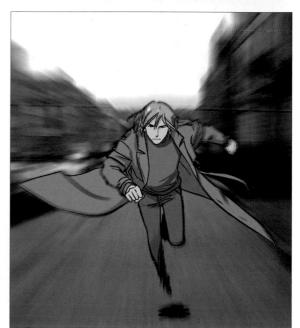

With the selection on, use the Radial Blur filter again, this time using a smaller blur amount. Use [Ctrl]+D to deselect the area around your character to see the result: a character in sharp focus while the background recedes at speed.

Creating a metallic look

In black and white manga, the texture of metal is always expressed through a mixture of toned shades and strong, contrasting highlights. While it usually looks convincing on a printed page, such approximations are the best you can get in black and white. In digital colour, however, you have far

greater opportunity for photo-realism, or at least for a higherquality approach to texturization. While there are laborious processes that are highly rewarding, it is easy to create a realistic metal effect by applying filters to your coloured line work. The examples below will show you how.

Practice exercise: Metal armour

There are many ways to create metallic effects: from sampling photographic metallic textures and blending them on a 'Multiply' layer with coloured artwork, to painstakingly building up layers of shade and reflection piece by piece using a soft-edged brush, often using photo-reference. This method is much more straightforward, offering an easily created metallic texture with the individuality of hand-applied reflections and light 'blooms' on the metalwork. Use of textures in this way ensures that the objects on your page don't just look like different-coloured versions of the same substance: gold, bronze, silver and iron all respond differently to light. This exercise will take you step by step through the process of applying a metallic texture to the body armour of a futuristic warrior, from line art to finished composite.

1 Open your line art in Photoshop, and prepare it for colour, fixing errors or dirt marks and separating lines from the white background.

As practised in previous chapters, fill in the flat colours. Colour in shadows using the cel-shading method, everywhere but the armour.

3 Use the Magic Wand Tool to select all of the armour areas and then go to Filter > Noise > Add Noise. Choose 'Uniform' and check 'Monochromatic' and set a medium value for the amount of noise to be added, then view the effect in the preview window. When you are happy with the amount, click OK to apply the noise to the armour.

A Keep the selection on and go to Filter > Blur > Motion Blur. Set the angle to ensure it blurs in the same direction as the incline of the body. In our example, the character's body is leaning to the left, so we set the angle to -63 degrees. Clicking OK applies the effect: you can already see the texture of steel in the armour plate.

Tip: Not all metals are the same, so it can help to build up a reference library of photographs and panels from your favourite manga of metallic effects, as such a resource may prove useful. Some metals, particularly those with elements of iron in their makeup, will also be subject to rust, which can prove to be an interesting effect for aged or weathered weapons, armour or vehicles. Use a separate layer and a textured brush to apply different shades of brown and gold to joints, wheel trims, handles and edges, or anywhere likely to have suffered from water damage. Rust can add a great deal of character, suggesting great age, or implying a lack of care on the part of an item's owner.

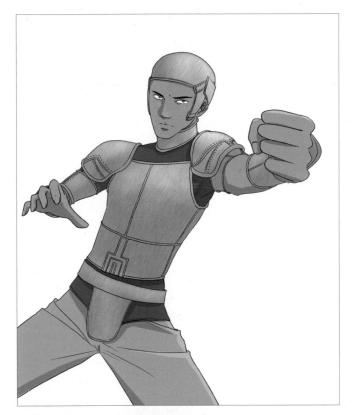

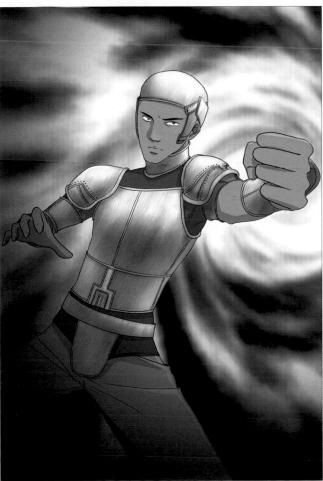

Now you can add the first layer of highlights and reflections to the armour. Duplicate the layer first so you can return to the original if you are unhappy with your modifications. Hide the original and work on the duplicate. For the highlights, use the Dodge Tool. Pick a brush with a soft edge, set its range to 'Highlights' and its Exposure to roughly 7%. Use a large brush to paint over areas that face the light source. In this case, the light source is from above and to the right. Be gentle with your brushstrokes, and don't obscure too much texture at this stage.

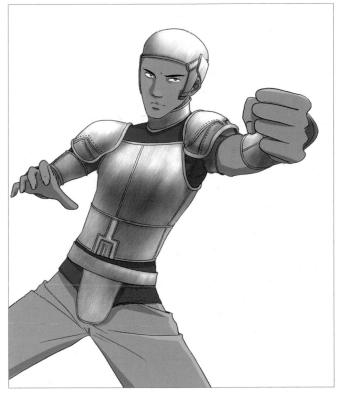

Still using the Dodge Tool, apply the more extreme, shiny highlights to the metal – an important step in your presentation of the material. Apply the Dodge Tool most heavily in the areas that should be shiniest, reducing the colour almost to white as necessary. When this is complete, add some shading and darker areas to the armour by switching to the Burn Tool. Use the same settings: a range set to 'Highlights' and an Exposure of around 7%. Gently paint over the areas facing away from the light with a soft brush, in this case the centre of the chest and the undersides of the helmet, throat and shoulder pads. Use the Dodge Tool to add further elements of reflection if needed.

As a final step, alter the colour balance to your satisfaction with Image > Adjustments > Color Balance. Set Tone Balance to 'Highlights' and uncheck 'Preserve Luminosity'. Don't oversaturate the armour; keep it tinted a silverish hue. Cyan and yellow were added to make the metal more realistic, and a background taken from an altered photo was inserted to make the shot more dramatic.

Creating reflections

Drawing precise reflections freehand usually involves many hours of painstaking labour, the judicious use of mirrors and the occasional bout of advanced mathematics. The majority of reflections found in manga drawn with traditional media tend to be rough approximations: a character looking in a mirror isn't too much of a stretch, but the same character looking into a pool of water may see his or her reflection as a series of wiggly lines, or some splotches of tone or colour.

Photoshop, however, with its array of layers and tools and filters to copy, flip, rotate, mirror and blur, proves to be the perfect vehicle for creating such reflective moments. The example on this spread shows how to create a reflection in a pool of water, but you could just as easily extend this technique to a mirror viewed side-on, the reflective gateway to another dimension, or an angry biker reflected in the windscreen of the car he is about to demolish. Experiment.

Practice exercise: Dreamy reflection

As mentioned above, traditionally drawing reflective water requires a lot of skill and the investment of a great deal of time on the part of the artist. Thanks

to Photoshop, we can now do it in a few steps. Remember that Photoshop is not so advanced that it can reflect elements you have not drawn: this technique works best for reflections viewed from a side-on perspective, not the back of head/front of head examples mentioned earlier.

1 Open your line art in Photoshop: here, a fairy lightly touching some water with her foot. Of course, the 'touching the water' part is yet to be added. First, prepare the line art for colour, tidying it and separating the lines from the white canvas. Colour the fairy as you have learned previously: soft shading adds a dreamlike quality to the fantasy character.

2 Underneath the character colour layers, create a new layer named 'Water'. Pick an aquatic blue and fill this layer with a gradient of white to blue, from dark blue at the bottom of the image to white at the top.

Tip: If you are feeling adventurous, you could try to blend a photograph you have taken of a body of water with the blue/white gradient, in order to give it texture and realism. Place the photo beneath the gradient and set the Gradient blend mode to 'Color', altering the fill Opacity of the layer as appropriate.

Duplicate the line art and the character colours layer and merge these duplicated layers together. Rename this merged layer 'Reflection' and move it underneath the original character colour layer. This, as the name suggests, is where you will create your reflection. First, the reflection must be correctly oriented. Use Edit > Transform > Flip Vertical to flip 'Reflection' upside down. Scale the image down vertically using the Transform controls so the reflection is smaller than the original version, then move the reflection up the canvas to meet the original's extended foot.

A Still on the 'Reflection' layer, go to Filter > Distort > Ripple. Here, you can choose the amount and size of the ripple's distortion; you can also preview what the revised image will look like in the preview window. Click OK when you find a result you are happy with. Your 'Reflection' layer is now wrinkled up to simulate the effect of flowing water.

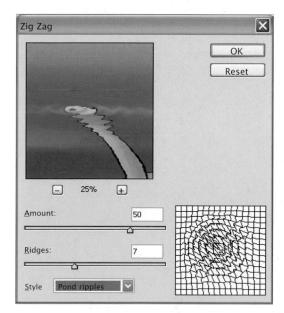

At the point on the merged 'Water' layer where the foot of the fairy meets the surface, make an elliptical selection with the Elliptical Marquee Tool. Then go to Filter > Distort > Zig Zag. Choose 'Rough Ripples'. Set the Amount and Ridges while looking at the effect in the preview window. Click OK when you are satisfied.

The reflection is too bright and saturated. Turn down the Layer Fill Opacity to 80%. The reflection in the water should also be blueish. To achieve this, duplicate the 'Water' layer and move the duplicate on top of 'Reflection'. Set the duplicate's blending mode to Hue and set the layer fill Opacity to around 50%.

Now merge the 'Water', 'Water Copy' and 'Reflection' layers together. You can draw some water effects on this new merged layer to simulate a water texture. Use the Dodge and Burn tools with a soft brush to make horizontal strokes on the surface of the water. You can also use the Desaturate Tool (located on the same button as the Dodge and Burn tools) to tone down some areas of the water, creating a spread of different hues.

8 On top of all the colour layers, create a new layer for your finishing touches. In this example, an array of sparkling reflections were added to lend the water a more magical, romantic feel.

Converting a photo

Backgrounds are often the most difficult and time-consuming element of a manga page, and even the most successful manga professionals are often resistant to illustrating them from scratch. While you have learned how to ink a background from your own photograph in the previous chapter, there is an even 'lazier' method of background creation for those in a deadline-bind or inspiration furrow. If you use this method too often where it is stylistically inappropriate, your talent will be called into question, so keep your actual background illustration skills up to scratch.

Practice exercise: Turning a photo into lines

The process behind this exercise is basically that of reducing a full-colour photograph to a two-tone bitmap, and then building it back up into a greytoned or coloured image.

Open the photo you want to use. For best results, the image needs to be at a large size (a mininum of 300 dpi is recommended), with sharp detail, taken in clear (though not overpowering) daylight. First, convert the photo to Grayscale using Image > Mode > Grayscale. Duplicate the layer and work on that, saving the original image for later use.

The method may sound longwinded, but it is, in reality, anything but. Remember to use your own photos, rather than copyrighted imagery.

Shadow/Highlight

Shadows

Amount

At the moment, the highlights and shadows in our example photo are too extreme. To fix this, use Image > Adjustments > Shadow/Highlight. In the options window, move both sliders to the highest value. The results are shown at left.

100

100

Reset

Load.

Save..

Preview

Now go to Image > Adjustments >
Threshold and bring up the options window.

Check 'Preview' and move the Threshold Level slider. Watch the changes in your image: your 'sweet spot' is when there is still detail in your black lines, but not too many areas of solid black. Click OK to apply the adjustment, creating a black and white image.

It is likely that your picture will still look messy thanks to some extraneous patches of black. Use the Eraser Tool to clear these, if necessary. Some areas in extreme highlight may have vanished, so use the Pencil Tool to fix these. If you want to add more details to the converted image, turn on the original layer and set the current layer to 'Multiply' and trace the appropriate lines. Eventually you will have a line art representation of your original photo. Drag this to your manga page and cut or Transform to fit.

Practice exercise: Tone the converted image

The photo is already converted to a black and white background. If you wish, you can either add tones manually, as before, or use the original photo to do the job, as below.

1 Use the same file as in the previous exercise. Drag the original photo layer to a new canvas at the same resolution. Use Brightness/Contrast to brighten the image and reduce the contrast a little. Now go to Image > Mode >

Bitmap. Select 'Halftone Screen' as your conversion Method. The image changes to a dotted bitmap picture, as shown above. If the conversion looks successful, switch back to 'Grayscale' mode.

Re-import your grey tone layer into your original document, behind your black and white background layer. Match the tones with the lines. The line art layer must be in 'Multiply' mode in order for you to see the tones beneath.

Practice exercise: Colour the converted image

Colouring the photo yourself will help soften the blow of 'cheating' by using the previous steps, but if time is really tight, you can colour the image using the actual photo.

1 Change the mode of your line art background file to RGB, and set the line art layer to 'Multiply' mode. Open your original colour photo and drag it into your black and white document, underneath the converted line art. The points should match up. Duplicate the colour photo layer, make the original invisible, and only work on the duplicated layer from now on.

Q Go to Filter > Artistic > Dry Brush and apply the filter. Use the preview window to try out all of the options. Click OK when you find the best effect.

Tip: Try layering a colour or gradient 'wash' (a layer set to 'Color' or 'Hue' blending modes) in between the colour photograph and the line art to create atmosphere.

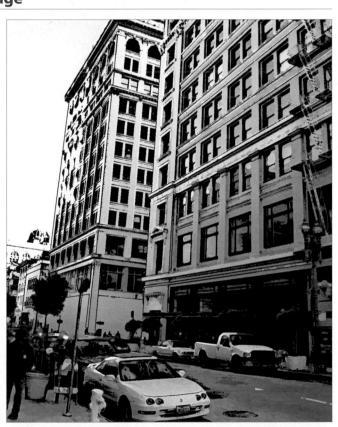

Adjust the Brightness/Contrast of the colour to ensure the line art stands out enough. You may need to adjust the Hue/Saturation or Color Balance of the colouring if you need it to fit into the rest of your manga page. Remember that there are other filters you can use to get the hand-coloured effect, so sample those if you need to.

Creating lighting

Although shadows and highlights are applied during the colouring process to indicate the presence or otherwise of light, it is useful to know that these simple methods can be improved or jazzed up with a Photoshop filter effect. This is not to say that there is a shortcut to the rendering of light and

shade with colour and brush: there is no quick fix. However, using a lighting filter in tandem with other methods can bring an extra dimension to your artwork, capturing, say, the bloom of candles in ways difficult to accomplish by hand. The following exercise shows one such method.

Practice exercise: Add digital lighting

As previously mentioned, digital lighting is a way of adding a final touch to an image, not a colouring shortcut. However, rather than an element you bolt on at the last minute, it helps you to bear in mind your lighting effects from the very first pencil stroke. Digital, single-source lighting is often most effective when unbounded by line work, which is why there is no candle flame illustrated in the example, just a wick and candlestick. Your shadows and highlights, likewise, are reacting to a light source you are yet to add. Follow the steps to light the candle.

1 Open the line art as usual: our example here is of a scared-looking elven girl holding a candle. For the most dramatic lighting effects, the image will be in darkness, the candle the only light source. Add the flat colours, using a purple-blue as the background to indicate a deep darkness. Keep the colours desaturated as darkness trends colours towards grey.

Tip: This type of image works best when there are clear extremes between light and dark, illuminated by a single, dominant light source that can provide a focal point in the image for the reader. To gather reference on how a single light source casts shadows on a face, use a desk lamp and a digital camera to take photos of yourself from different angles.

2 On another 'Multiply' layer, add shadows. Pay particular attention to the light source, the candle, as everything not facing it should be in shadow. Grey-purple is used for shading, another element to represent the dark of night. Add highlights on a separate layer.

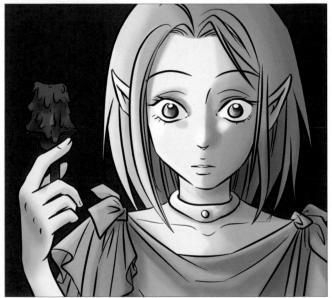

When you are happy with your highlights and shadows, make a copy of all three colour layers and merge the copies together into a single layer. Place the merged layer on top of the original colours. Next, we will apply the filters on this merged layer.

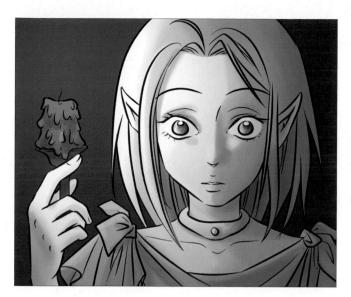

Go to Filter > Render > Lighting Effects. In the option window, choose the Light Type as 'Omni', sliding the option bars and keeping an eye on the preview in the preview window. You should not make the intensity of the lighting too high, as that will make any areas affected by the light lose their colours. Clicking OK applies the lighting effect.

When this is done, deselect the area and go to Filter > Blur > Gaussian Blur to blur the candlelight, allowing it to merge convincingly with the background.

Tip: Take a look at photographs of flames to see how they behave in different volumes: you could create the light from a campfire with multiple freehand

selections, for instance.

With the nimbus of 5° With the nimbus of the light applied, you next need to add in the candle flame. Create a new layer on top of the other colour layers first. Use the Elliptical Marquee Tool to make a small, rough selection on top of the candlewick: don't worry about being precise, an approximate area will do. Use the Gradient Tool to apply a Radial gradient to the selection: set the foreground colour to bright orange and the background colour to a bright yellow.

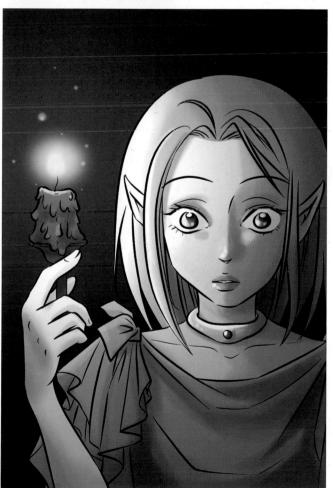

If the light doesn't look bright enough, use the Dodge Tool with the range set to 'Highlights', to dodge the middle of the flame. Add flame and spark details and adjust the overall colours using Color Balance and Brightness/Contrast.

Combining software

For those with the budget to experiment and the time to get to know new software, the best part about the latest home computers is the range of graphics packages available. While Photoshop is incredibly flexible, many manga artists use Adobe Illustrator for its infinite scalability and editability of lines (an Illustrator document can be printed, without loss of resolution, at the size of a postage stamp or an office block), or Corel Painter for its wide range of well-simulated natural media. Often, images will be transferred between multiple packages, the better to take advantage of the strengths of

each: line work drawn in Illustrator can be transferred to Photoshop for colouring, as Illustrator is best for bold, graphic images and type, while images can pass between Photoshop and Painter to take full advantage of the digital replications of chalks, paints, pastels and oils to be found within. The examples below combine Photoshop and Painter. It is simple to lay in flat colours with Photoshop and then switch to Painter for a more naturally painted look. For cel shading or unfussy soft shading, Photoshop is easily sufficient, but the examples below give you an extra option.

Photoshop and Painter

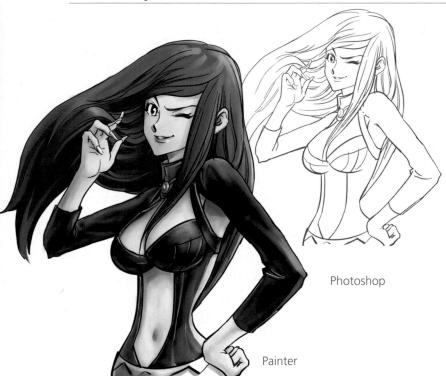

It is easy to show the differences between Photoshop and Painter. While Photoshop can do its best to simulate natural media with a range of brushes, textures and opacities, the results are still just combinations of various levels of colour: a 20% white over a 50% green, for example. Painter, on the other hand, has swathes of algorithms dedicated to reproducing the feel of natural media. Painter can simulate different styles of painting, from watercolours to pastels and oils, each of which allows the colours to act like 'real' pigments: blending, blurring, seeping naturally into one another, sitting in lumps on the canvas, picking up the texture of the page, and so on – all with the full levels of Undo provided by the digital realm. It can often be hard to tell the image has been created digitally at all.

■ Different strokes

The image on the right, from Photoshop, clearly shows the digital crispness in the line art that is the package's strong point, while the example from Painter displays the effortless blending and natural textures for which it is famous. Either image can now be imported into the other package for further tinkering.

Switching between programs

It is easy to move files back and forth between Painter and Photoshop, but there are a few places where the translation is not exact (mainly for patent reasons).

- Use the .psd format to save files.
 The layers and quality will be best preserved when the file is moved.
- RGB is Painter's native colour mode.
 Although Painter can open files in CMYK, for best results it is better to stick to RGB if exporting to Painter.
- A Photoshop document without a Background layer will open in Painter as layers over a white background.
- Painter and Photoshop recognize most of the other's layer modes (Photoshop calls them blending modes, Painter compositing modes), but they have different names. For example, 'Magic Combine' in Painter is 'Lighten' in Photoshop, while 'Shadow Map' is Photoshop's 'Multiply'. There are some layer modes they cannot recognize: they will default to the basic layer mode.
- Photoshop type layers will be rasterized when imported to Painter.
 Don't letter pages before you have finished with Painter.

Painter interface

Many of the Painter tools have clear Photoshop equivalents; the interface and menus are just as intuitive.

Practice exercise: Combined image

1 Open the line art in Photoshop. Fill in the flat colours and save the file as a .psd with layers. Close Photoshop and open Corel Painter (don't close Photoshop if your computer is powerful enough). Go to File > Open to open the .psd file.

Make a new layer, clicking the icon at the bottom of the Layers Palette. You will use mainly Digital Watercolor to paint this image. Select the skin areas using the Magic Wand first. Click on the Brushes, choose Digital Watercolor and pick the Simple Water Brush in the drop-down list. Choose a skin colour in the color palette or pick it from the flats using the Eyedropper Tool (J).

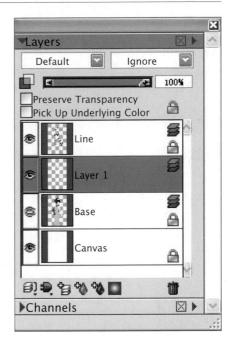

Using a large brush, paint the basic skin colour. Dry the colour with Layers > Dry Digital Watercolor. Pick up darker shades of the skintone, using a smaller brush to build up shadow and detail. Dry the watercolour when finished. (Please note: only skin tones show on this layer.)

Save the image as a .psd file and open it back in Photoshop. First, blur the pattern layer using Filter > Blur > Gaussian Blur, with the blur set to a low radius. Next, change the layer blending mode to 'Screen'. The pattern now looks elegant and delicate, almost etched into the fabric.

A Select the Oils Brush and use a Thick Oil Bristle Brush to paint highlights in white. Use a mix of these two techniques to colour the rest of the image.

To add interest to the illustration. you could add a pattern to the kimono. Add a new layer above the colouring layers. In the Brush drop-down list, choose Image Hose, then Spray-Size-P, Angle-R. In the toolbox, click the icon at the bottom right to choose a pattern: here, the pattern is 'Bay Leaves'. Spray areas where you want the pattern, clearing excess areas with the Eraser Tool. At the moment the pattern doesn't look quite right: it is too bright and the wrong colour, but you will fix this in Photoshop.

Merge this pattern layer with your colours. If you want to change the hue of any area, now is the time to do so. Photoshop has a stronger post-colouring editing ability than Painter, which finds the process awkward.

Digital shojo project

Shojo manga is largely aimed at young and teenage girls, and the artwork tends to be feminine and romantic. Shojo stories revolve around a female protagonist, and though they can take place in any genre, the focus of the story tends to be on the protagonist's search for love. Typically, there are many more panels depicting subtle changes of facial expression and a greater emphasis on feelings than in other manga, as well as specific visual cues that are rarely seen outside of shojo. As an example, flowers, bubbles or hearts surrounding a figure will give clues to her emotional state: romantic scenes of a similar ilk would be played for laughs in a shonen manga.

This project will show you how to create a typical shojo page, with an airy, panel-light layout, ornamental flowers, and tight focus on the central figures.

Leave-taking ▶

A warrior goes off to battle, his lover bids him goodbye ... before he offers her the chance to adventure at his side. The ornamental flowers speak of our heroine's love, but also press in around her claustrophobically, presaging the sadness she would feel in her lover's absence.

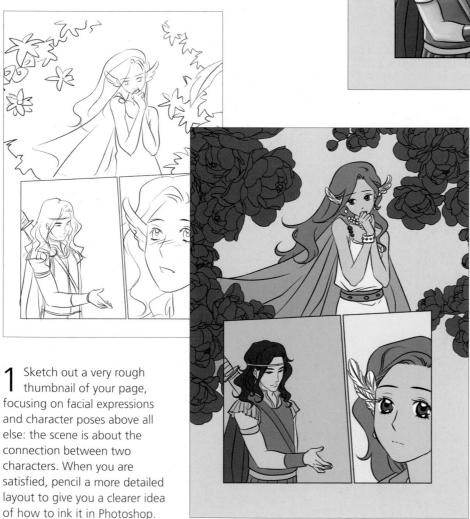

WHEN ARE YOU COMING BACK?

BUT YOU CAN COME WITH ME.

Import the pencilled image into Photoshop using a scanner, at a resolution of at least 300 dpi. Convert the file to Grayscale and ink it digitally using the Brush Tool as you learned earlier, cleaning with the Eraser Tool and sharpening lines with the Pencil Tool as appropriate. Once you have finished, delete the rough image layer and add a new layer of white underneath the inks. Convert the image to RGB.

Create a new 'Normal' layer between the existing two and name it 'Flats'. On this layer, use the Paint Bucket Tool to fill the basic colours, using the Pencil Tool to seal improperly sealed areas if necessary, or to fill awkward nooks and crannies. Adjust the colours with the Hue/Saturation options (Image > Adjustments > Hue/Saturation) until you are content with the final result.

The soft shading colouring method is best suited to creating a romantic atmosphere. Duplicate 'Flats', rename the duplicated layer 'Colour' and set the mode to 'Normal'. Lock the 'Flats' layer, and use it to make selections of areas with the Magic Wand. On the 'Colours' layer, choose slightly darker colours than your original flats and use a soft brush with Opacity and Flow of around 30% to gradually build up the shading. Use still darker versions of the same hues to give the image depth by painting in darker shadows using a smaller brush.

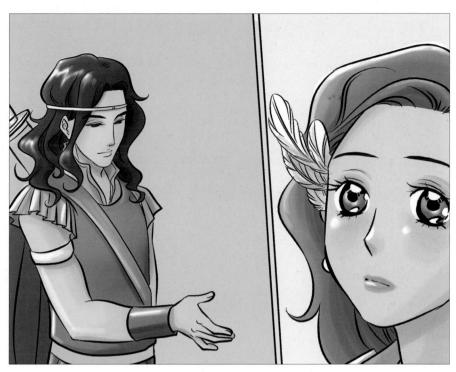

You can either add your highlights on the currently active layer, or create a new 'Normal' layer and work on that. The second method is usually preferred, as it is easier to correct mistakes and will not interfere with your previously applied shading. Select lighter colours than your original flats and build up your layers of highlights with a brush as in the previous step. Add a bright white highlight, sparingly, on shiriy areas that face the light. Add shine, shadow and detail to small areas you may have missed, such as the cheeks, lips, eyes and accessories.

5 At present, the backgrounds are still very flat, and lacking in ambience. It is a very simple matter to select the flat areas on the 'Flats' layer and use the Dodge Tool to add flares of light to the areas of flat blue. The roses can be toned using the same soft-shading method used to colour the characters.

Tip: Experiment further with the use of abstract backgrounds: why not select all of the black lines making up the roses with a Lasso Tool and use the Paint Bucket Tool to colour the black a deep shade of pink? This 'knocks back' the line work even further and brings your characters to the fore.

The colours are complete: you just need to add your speech balloons. Use the Text Tool to type in dialogue in your chosen font, centring the text and arranging the content of each balloon in a roughly elliptical shape. Create a new layer underneath the text. Use the Filled Ellipse Tool with white as the foreground colour to draw balloons, moving the text to fit as necessary. Draw tails. Select the balloons using the Magic Wand Tool, and use Select > Modify > Border to add a 4–5 pixel empty selection around them. Fill this with black.

Digital shonen project

Compared to shojo, shonen manga is traditionally aimed at young and teenage boys. However, with the unisex success stories of manga like *Naruto*, today you are just as likely to find girls reading them too. Shonen manga is usually packed with fast-moving action and often focuses on a male protagonist.

This project will guide you in the creation of an action-packed shonen page: a pulse-pounding fight scene between our teen heroes and some angry, ambulatory trees.

Arboreal action ▶

There's no time to pause for breath in this thrilling, fantasy action scene. Impacts are heightened to a physically impossible level to sell the extreme power involved.

Begin by sketching out a rough thumbnail of the whole page. Here, the first two panels take up most of the page to show the scale and impact of the fight. At a larger scale, and still in pencil, create a more detailed, rough layout. The example above shows only a portion of the full page at this stage. Remember that you are creating a guide to make digitally inking your page easier in the next step.

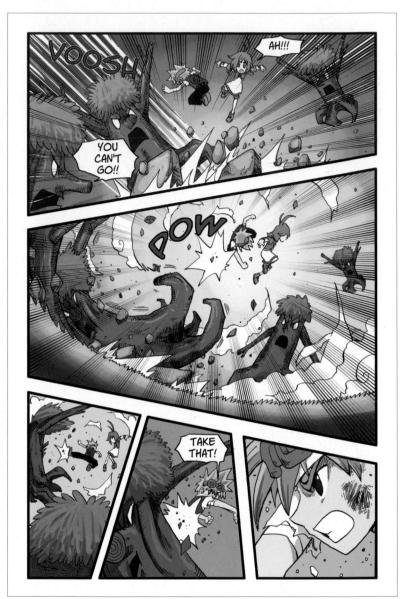

Before scanning your page, add 2 some more textural details in pencil, such as the bark of the trees or the exploding rock. When you are happy, import the detailed rough into Photoshop, scanning the page at a minimum resolution of 300 dpi. Convert the page to Grayscale mode and digitally ink the lines on a separate layer. Build up line weights by using different-sized brushes or going over existing lines. After you have finished inking, add a white background layer underneath the inking layer and delete your original rough pencils.

To begin colouring, change the mode to RGB. Add a new 'Normal' layer between the inks and white background: call it 'Flats'. Fill in your flat colours using the Paint Bucket Tool, sealing areas with the Pencil Tool as required, or using the Pencil Tool to colour in awkward areas in the line work.

5 Backgrounds of solid colour leave the page looking flat. Add variations to make it look more vibrant. Duplicate 'Flats' and hide the original. Use the duplicate to select the backgrounds of panels 1 and 2, and the Dodge Tool to lighten the areas around the focal points: in panel 1, where the ground is breaking; in panel 2, the main characters.

The cel-shaded method works best for this project. Create a new 'Multiply' layer on top of 'Flats': call it 'Shading'. Using a light grey brush, paint areas of shadow. Use the 'Flats' layer to select colour areas using the Magic Wand Tool. Add another 'Multiply' layer above 'Shading' and call it 'Shadows': brush areas with a darker grey. Finally, create a new 'Normal' layer above the shadows called 'Highlights'. Add highlights in lighter colours facing the light source.

To make the page more dramatic, add some speedlines. Use a stock image you have prepared earlier. Drag the speedlines to your image, Transform them to fit, and Erase unwanted lines. Add colour gradients to the lines and use layer blend and Opacity settings to integrate them.

Now, add dialogue and balloons.
Add the dialogue using the Text
Tool, and draw balloons on a layer
underneath. Jagged balloons amp up
the drama: draw them freehand with a
Pencil Tool or Lasso Tool, fill them with
black, then select them with the Magic
Wand Tool, Contract the selection by
4–5 pixels, and fill with white.

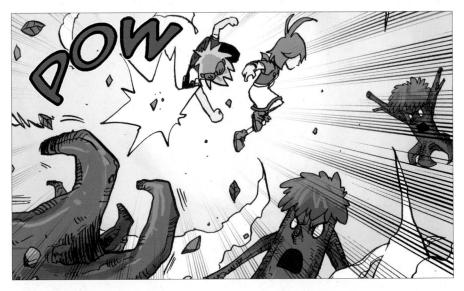

Sound effects are very important to shonen manga, especially in the high-stakes environment of a fight scene. Accompany every jarring impact with a tooth-rattling piece of SFX, adding coloured borders to manipulated text.

Digital kodomo project

Kodomo manga is aimed at younger children. It is often educational, based around the acquisition of vocabulary in a fun, adventurous context. Few kodomo manga have been exported to the West, aside from famous brands such as *Hello Kitty* and *Doraemon*. Kodomo can accommodate many genres, so long as they are child-friendly and use relatively simple dialogue.

This project will show you how to create a typical kodomo page. The key is to keep everything simple and the characters cute.

Rampaging robot ▶

Note how the giant robot manages to look threatening and safe at the same time: the bulbous body and rounded edge make him a cute antagonist. Note, too, the bright colours, simple dialogue and reasonable font size.

1 Draw a thumbnail version of your page in pencil, sketching in your characters and the layout of the entire page. The dominant entity on this page is the giant robot, so make that the focus.

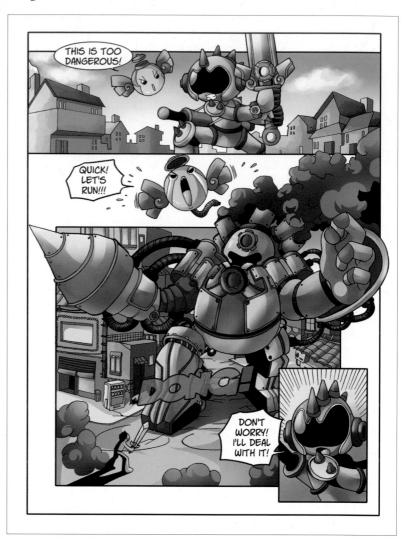

2 Create a scaled-up, more detailed version of your rough illustration with enough information to ink over.

3 Import the rough into Photoshop using a scanner, scanning it at a minimum resolution of 300 dpi. Convert the file to Grayscale and digitally ink it on a layer above your rough pencils. Keep the lines clean, bold, simple and open for colour, using bold outlines around your characters to separate them from the background. When the inks are finished, delete the roughs and add a white layer underneath.

Add a new layer between the inks and the white background layers, setting the mode to 'Normal' and naming it 'Flats'. Fill in the flat colours on this layer, choosing bright and attractive colours, erring on the side of visual interest rather than fidelity to real life. For example, the robot's smoke is here a bright orange, rather than a dull grey.

On a new 'Multiply' layer named 'Shading', use a light grey brush to add shadows, using the 'Flats' layer to make selections. Adjust the greys with Hue/ Saturation to make individual parts of the image more colourful.

Create another new 'Multiply' layer, name it 'Shadows' and add darker shadows again. Use a soft brush with Opacity set to 30% to give the dark shadows a more realistic, blended look, especially on the belching smoke and the blue sky in panel 1.

Add a 'Normal' layer named 'Highlights' above the colour layers. Use a soft brush with Opacity set to 30% to lighten areas facing the light source, especially on the robot and the armoured boy. Use solid white to pick out extreme highlights.

Tip: Use bold and contrasting colours that leap out at the eye — note the interplay between the blue and the orange in this example. Pick up children's picture books for the very young and take inspiration from their heightened, almost primary palettes.

Make a new 'Normal' layer for details on top of 'Highlights'. Use the same soft brush as in previous steps to paint some reflected colours on to your metallic, armoured elements, and add some wispy clouds to the sky in the first panel.

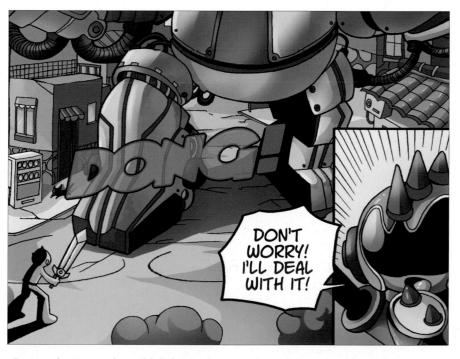

9 Use the Text tool to add dialogue, keeping the point size large and the vocabulary age-appropriate. Draw speech balloons on a layer beneath the dialogue and fill them with white as before; and then, as a final step, add some SFX.

Digital seinen project

Like shonen, seinen is aimed at males, but its target demographic is several years older - teens and twentysomethings - and it also has a following among an older audience of people up to about forty years old. It normally attracts young people who are moving away from shonen and shojo. Seinen has a lot of overlaps with shonen, but will accommodate more mature themes, whether that be the 'maturity' of graphic violence, sex and nudity, or more adult approaches to inner feelings and emotional states. Seinen protagonists will also be older than shonen stars.

This project shows how to illustrate a typical seinen page in a relatively realistic style.

First date ▶

At a surface level, this page from a romantic comedy could be mistaken for a shojo tale, but note that although the woman is shown in close-up panels, the focal point of our attention is the man: it is his thoughts to which we are granted access.

Sketch out a very rough thumbnail in pencil to plan your page. As the scene is very 'talky' and not very dynamic, here each panel has been given a different perspective in order to add visual excitement.

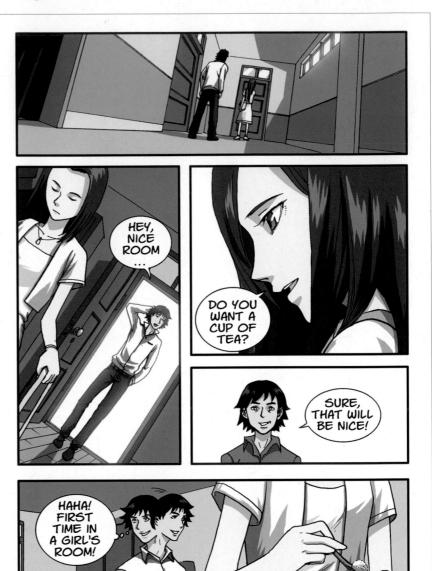

 $\label{eq:problem} \begin{tabular}{ll} \bf 2 & {\tt Detail the rough in pencil to your satisfaction, and import it into Photoshop by scanner at a minimum of 300 dpi. Digitally ink the Grayscale roughs on a separate layer, then delete the rough when you have finished. Add a layer filled with white underneath the inks as a plain background. \\ \end{tabular}$

3 Create a 'Flats' layer between the background and inks, and block in flat colours. Keep the colours muted to suit the realistic tone: browns, greys, greens and pale blues. The purples and pinks of the woman make her stand out.

Create a 'Normal' layer called 'Highlights'. Select the area you want to add highlights to using 'Flats'. Pick the appropriate colour from the 'Flats' layer, make it lighter in the Colour Palette, then paint the area using a brush.

Finally, add some effects to the page using another layer. To add the effect of light coming from the windows and door, use an 'Overlay' layer on top of all layers (including inks) and paint over the image using a light yellow.

This page best suits the cel-shading method. Add a new 'Multiply' layer called 'Shading' on top of the 'Flats', painting your shadows on this layer using a hard brush. Change the shaded colour from grey to a darker version of the area you are shading if it looks better. Use the 'Flats' layer to make your selections using the Magic Wand Tool.

On a new 'Multiply' layer named 'Shadows', added on top of the 'Shading' layer, deepen your shadowed areas by using a darker grey. Use this on areas such as the woman's hair (in the detailed close-up), the man's collar and behind the door.

Now add your dialogue to the page, using the Text Tool to input and layout the conversation between your characters, as well as detailing the thoughts of your male lead. Create a 'Normal' layer for balloons beneath the text layer. Draw the balloons with the Ellipse Tool. Set the foreground colour to white and check 'Fill Pixels' in the Options Bar. Draw tails pointing towards the right characters (thought balloons need a trail of dots). Select all the white balloons using the Magic Wand Tool and use Select > Modify > Border to add an empty selection of 4–5 pixels to each balloon. Fill this selection with black to create your finished balloons. Move the text or Transform your balloons to fit.

The history of anime

'Anime' is coined from half of animation – literally 'anima', pronounced 'a-nee-may' – and is the common description for Japanese animated films and television shows. A large proportion of anime is based on popular manga. This means many, if not all, of the titles that have blazed to print popularity are also available as TV series or films. Long-running anime will often hit between 200 and 600 episodes before

coming to a close. It is often said that the reason the Japanese took so strongly to anime is that their own live-action industry was so small compared to the mass-production factories found, for instance, in Los Angeles. Anime offered limitless possibilities for the filmmaker – in scenery, cast of characters and storytelling. The only barrier to the imagination was the time it took to transfer an idea from brain to transparent cel.

Format

Anime is released either through TV syndication - often as half-hour, 26episode series – or as Original Video Animations (OVAs). For years, 'anime' was synonymous with low-quality animation. While the drawings and storylines would be of a high standard, the number of frames per second was low, for fiscal expediency. These costcutting measures often led to the stylistic tics we associate with anime: frames where little but the mouth and eves move; lengthy pans across still, painted backdrops; and 'money shots', where an important sequence is animated with more frames than the surrounding animation.

Pokémon A

One of the most popular exports of children's anime in recent years has been the *Pokémon* series of films and TV shows, all based on the Nintendo Game Boy series of games.

First steps

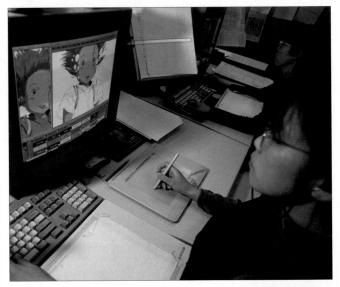

■ Studio work

A woman works in digital animation at Studio Ghibli in Tokyo. Colour is now often applied on the computer, which, along with the ability to add more frames, leads to a newfound digital smoothness in many anime.

The first true 'anime' is considered to be *Hakujaden*, or *The Tale of the White Serpent*, released by Toei Animation in 1958. Like the new wave of manga, it wore its Disney influences on its sleeve, and was a great success. Toei continued to release such films throughout the 1960s and 70s, eventually becoming a lynchpin of television with *Dragon Ball Z* and *Sailor Moon*.

Osamu Tezuka, the 'father of manga', was also heavily involved in the development of anime. He started a rival company to Toei, Mushi Productions, and released *Tetsuwan ATOM*, or *Astro Boy*, in 1963. Its success led to the creation of innumerable competing series, including similar success stories like *Tesujiin 28-go (Gigantor)*, *Mach Go Go Go (Speed Racer)* and *Jungle Emperor (Kimba The White Lion)*.

The anime form, like manga, encompasses every genre and type of narrative, from the straightforward to the more esoteric.

Print inspiration A

Manga-ka Katsuhiro Otomo began the screen adaptation of his magnum opus *Akira* years before the print story would be completed, leading the film to adapt only the first half of the epic.

Western breakthrough

The breakthrough in the Western awareness of anime was twofold: the cinematic release of *Akira* in 1989, and the rise of VHS. The expense of localizing a dub for each country meant such videos were expensive, but fans lapped them up. Ironically, at the point that anime films began their breakthrough, many Japanese studios were facing bankruptcy. With the death of Tezuka from cancer in 1989, a golden era of Japanese animation ended – but not before international curiosity had been piqued.

■ Spirited Away
This 2002
Hollywood press
conference at the
El Capitan Theater
marked another
high for the
international
popularity of Hayao
Miyazaki's films, and
the penetration of
anime culture into
the mainstream.

1990s and 2000s

The 1990s and 2000s saw many exciting developments in anime. including the the advent of multitracked DVDs (allowing multiple dubs and subtitles to be placed on a single disc), and increasing use of digital techniques to bring lush and impressive imagery to OVAs, films and anime series. Where films and television are concerned, highlights include the release of Ghost in the Shell in 1994, which captured the same adult-oriented market as Akira; Hideaki Anno's Neon Genesis Evangelion in 1995, which revolutionized and scandalized in equal measure; the runaway international success of Dragon Ball Z, Pokémon and Sailor Moon; and the release of Hayao Miyazaki's Princess Mononoke in 1997,

which was the most expensive animated film at that point. Miyazaki, and his Studio Ghibli, is one of the leading anime auteurs. The studio, created with the proceeds from Nausicaä of the Valley of the Wind, continues to capture critical and popular acclaim with titles such as Laputa: Castle in the Sky, Mononoke and Spirited Away.

After the millennium, big-budget, adult anime spectaculars in the form of *Appleseed* (2001) and *Steamboy* (2004),

Princess Mononoke ▼

The film was released to US and UK cinemas in both dubbed and subtitled versions, the dub version receiving a sympathetic translation from famed novelist Neil Gaiman.

among others, returned to the cinema screen. Television anime productions continue to push the envelopes of creativity, style and provocative content, while the popular manga *Death Note* and *Fullmetal Alchemist* have swiftly made the transition from page to screen. Last, but by no means least, 2008 saw the creation of the position of Anime Ambassador by the Japanese government: a post filled by Doraemon, a (fictional) time-travelling robotic cat.

Ashitaka, prince of the Emishi ▼ Miyazaki's films fuse environmental awareness and lush cinematography with more contemplative and spiritual layers – as the unusual, cursed hero

of Princess Mononoke illustrates.

Software

The first step in creating an animation is assembling all the tools you will need. There are certainly plenty of options to choose from. Fear not, however, as this section will introduce you to the most common digital animation software (and some hidden gems) so you'll have a good idea of what will suit you. It's worth investing a little time researching your tools,

and most will offer trial periods so you can give them a test-drive. All of these programs are updated with new versions on a regular (often annual) basis, but if it helps you save money, there's often little need to be on the bleeding-edge of technology, as older versions will often be just as powerful as the latest iterations.

Flash

Adobe Flash is an extremely popular vector-based animation program with a powerful scripting language. The current version is CS4, which incorporates advanced features such as 'bone-rigging' and 3-D object manipulation. Flash can import images from other programs to use as backgrounds or as sketches to work over, but also contains all the tools you need to create an animation from scratch. Being the most popular, Flash has many websites dedicated to tutorials, tips and free SFX which can be very welcoming for beginners.

Tip: Corel Painter is ideal for creating stunning backgrounds as it emulates natural media. This is because they look as if they have been traditionally painted. The latest version is Painter X, though Painter Essentials is a cheaper edition aimed at the casual user. While Painter has no animation features, it is included here as cel-style animation stands out better atop beautifully painted backgrounds. Find a couple of brushes and a blender you like and put them in a tool palette before you start painting, as too much choice can prove overwhelming.

◀ Flash animation

Flash can save your finished animations as video files which can be burnt to DVD, uploaded to YouTube or saved to its web-ready format (.SWF). Flash is more than just an animation package, which means you can even add interactive elements to your animation. While Flash is rather expensive, a free trial version can be downloaded from Adobe's website.

Toon Boom

Unlike Flash, the Toon Boom range of products focus solely on creating animation, so while not as versatile, they can feel less overwhelming. Toon Boom has software for every level of animator, catering for kids, home users and professional studios. Toon Boom Studio features everything you need to create great animations and remains competitively priced, though the top of the range costs significantly more. Toon Boom is great at importing and manipulating existing artwork and has all the tools animators need, like 'onion skinning', automatic gap-closing and a full-screen rotary light table so you can always draw at the most comfortable angle. Toon Boom Studio can export your animations to a massive variety of formats including .SWF and video to suit devices from iPods to HDTVs.

Ready for his close-up ▶

Here we see a zoomed-in element of the Toon Boom window: a painted cel against the light table grid that makes compositing and scaling so simple.

Drawing cels ▼

Using Photoshop's

can make it very

simple to draw

traditional cel

animations one

frame at a time.

powerful layer tools

Photoshop

Adobe Photoshop is a very powerful image-editing program which can be used for backgrounds, pixel/sprite animation or cel animation, although this versatility and power (and the fact it is universal image-editing software rather than a dedicated animation program) mean it's expensive. It can be tricky to use the animation window unless you're already familiar with Photoshop's layout and approach to layers, but as with all popular applications, you'll find dozens of tutorials online. Photoshop has had integrated animation capabilities since CS1, but in really old versions, the animation window can be found in the bundled software ImageReady (File > 'Edit in ImageReady').

EasyToon

EasyToon is mysterious little Japanese program (PC only) for creating preliminary 'pencil test' animations: basic sketched animations which are integral to making smooth and fluid progressions from frame to frame. While its functionality is limited, this makes it extremely effective and very quick to learn. A quick Internet search will find you a translated version, completely free to download.

Frame by frame A

'Onion skinning' effects show previous and next frames in different colours and levels of Opacity.

Fully painted background A

Photoshop is just as versatile as Painter when it comes to creating painted backdrops, although it doesn't attempt to simulate natural media.

AnimeStudio

While AnimeStudio is not a traditional animation tool, it's fantastic for very quickly creating single scenes that you can tweak and perfect. Avoiding frame-by-frame animation, AnimeStudio relies entirely on a bone-rigging system to animate 2-D characters' limbs from pose to pose, thus speeding up the animation process. Working in AnimeStudio is quick and fun – but the animating method is restrictive and only one scene can be produced at a time: multiple scenes need Flash or a video editor to compile them together. Its soundtrack capabilities are also very limited.

Bone-rigging ▶

Each element of the character is a separate 2-D vector graphic, 'mapped' on to a 3-D skeleton that can be animated like a puppet.

Tip: If you're thinking of creating 3-D animation, Maya is a popular high-end choice thanks to its modern layout and extreme flexibility. Although Maya can be very expensive, there are options for varying skill levels and even a free Personal Learning Edition to enable beginners to get to grips with its complexities before committing. As with all 3-D animation, creating objects and characters takes a long time, but once created they can be brought to life with stunning results. Maya also includes many shading and lighting effects: you can render your animation with 'Toon Shading' to recreate the anime look of painted cels.

Pre-production

The first step to a successful animation is planning. Before beginning to animate, it's important to refine your ideas. After all, if you redesign a character's hair halfway through production, you will find yourself tediously reworking all the frames you thought you were done with. Many anime are adapted from manga, which are in turn usually drawn from a written script. This process means the story, locations, characters and even the kind of shots to be used have all

already been considered. Even so, some details will need to be changed to suit animation. For example, many manga feature intricately detailed outfits that need simplifying for animation – removing buckles and frills or changing chainmail to plate at the beginning of a project can significantly reduce the man-hours involved. Whether based on your own manga, or on an idea that hasn't left your head yet, it's best to work out your animation in advance.

Creating your characters

Designing or adapting characters for animation doesn't differ greatly from other forms of character design, but there are a few things to bear in mind. First, the character should be simplified enough to draw efficiently thousands of times. Outfits, hairstyles and number of colours used can be simplified without losing the essence of the character. Patterned cloth can be replaced by flat colours, and soft shading represented by solid shadow.

Another thing to think about is 'secondary motion'. Also known as 'secondary animation', this is the name for reactive movements created from the main 'primary motion'. If a character is running, the secondary animation could be her hair bouncing and flowing behind her. When she stops, her hair will keep travelling (sometimes called

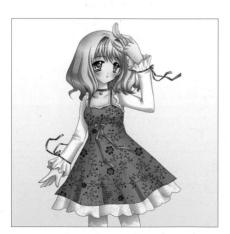

Original character

Here we have a manga character whom we wish to adapt for animation. Note the soft shading, the many individual strands of hair, the floral print on the dress, and the numerous, reflective colours in her eyes.

follow-through) before falling back down. Secondary motion creates smoother-looking animation and can be applied not only to hair, but ribbons, a karate headband, or anything light and loose.

Secondary motion ▶

This animation is best used to flow two distinct movements into one another: from walking to jumping, for instance, or from sitting to standing.

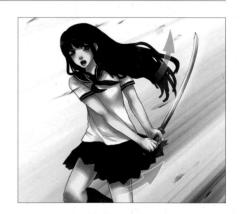

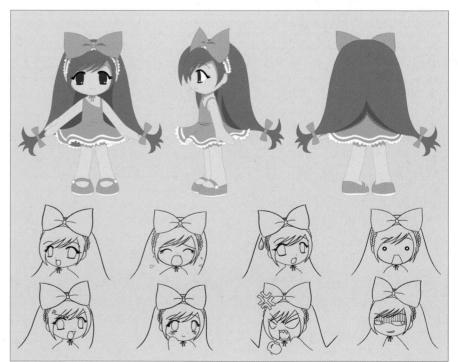

Revised model sheet for animation A

A model sheet – pinning down your designs in a uniform way – makes it easier to maintain consistency. This is important if you're collaborating with other people, as everyone involved will know how tall the character should be drawn, what colour their eyes are and so on. A good model sheet includes multiple character angles (called a turnaround) and the colour palette. Additional sketches show facial expressions, body language and other subtleties.

Storyboarding

It's good practice to get action and dialogue down on paper (or screen) in some form before beginning. Not only will this avoid production problems, but the process of recording your ideas will refine your story. You can animate directly from a screenplay or from manga, but storyboards will help you plan every aspect of what appears on screen. Draw a new storyboard for each change of action, angle or scene.

Planning >

A storyboard shows a sketch representing the scene with dialogue, sound effects and camera movements noted nearby.

Action: Hand inserts coin. **Camera:** Zoom in.

Shot: Close-up.

Action: Flicks

through pages, stops and looks up. **Camera:** Still.

Shot: Medium.

Action: Side view, walking left to right, yawning.

Camera: Still.

Shot: Medium.

Different perspectives

Cinematic shots, camera angles and movements will add style to your story, as well as help shape it. The examples to the right show various angles by which you can approach your scenes, each of which can present the same action in a different way.

While storyboarding, it's useful to think how you'll approach the actual animating. If a certain scene would be easier but no less effective from a different perspective, change it and save yourself valuable time later. Watch anime analytically: you will notice instances of timesaving 'limited animation' that can be planned for. Looped animations over a moving background, lower frame rates, extreme close-ups and panned stills are all examples of methods employed to save production time. Being efficient in this way leaves you extra time to perfect the most important sequences.

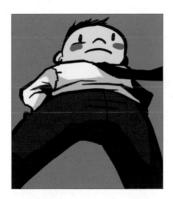

Looking up at the character from very low down. This grants the character a great deal of power.

Close-up ▲ Tightly framed shot, used to bring attention to an item of significance.

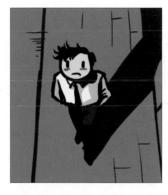

High angle ▲
Looking down at a character from high up makes the character look vulnerable, small and isolated.

Extreme close-up A Zoomed in on one part (the eyes, for example) to emphasize emotion.

Dutch angle ▲
Low-angled shot, but from a tilted angle. This is used to portray tension or create unease in the viewer.

Point-of-view ▲
Shows what a character can see, as if we are looking through their eyes.

Backgrounds

Character animation needs to be placed on top of a background to complete a scene. It is usually better to create the background (or at least a rough version) before beginning the animating process. Background styles vary widely, from the detailed painted backgrounds Studio Ghibli is famed for, to the fun and

Tip: You learned earlier how to create digital backgrounds from photographs, so why not apply the knowledge here? You can create extremely detailed background images with which your cel-shaded, wholly fantastical characters can interact.

Multi-layered ▶

If part of the foreground will obscure a character (here, a chain-link fence), the top layer can be designed and exported as a separate image. Most animation software will support images with transparency information (commonly using the .png format).

childish scribbled backgrounds of Digi Charat. No matter the style, remember to make your background at least as large as your animation window. In most cases, the background will be a single image depicting the set or location, but some scenes will need extra layers or effects, or be longer or taller to facilitate pans, zooms or tilted scenes

Pans

Panned (or scrolling) scenes should be much larger than the screen size, so that the 'camera' can move across the background to the full extent required by the scene.

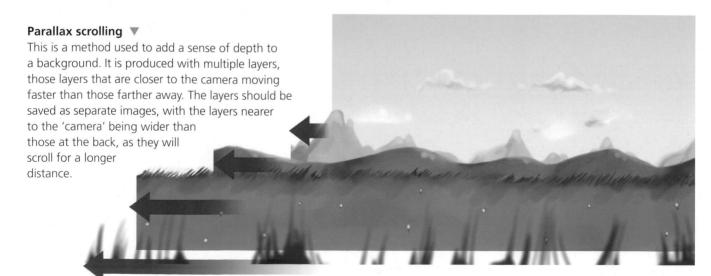

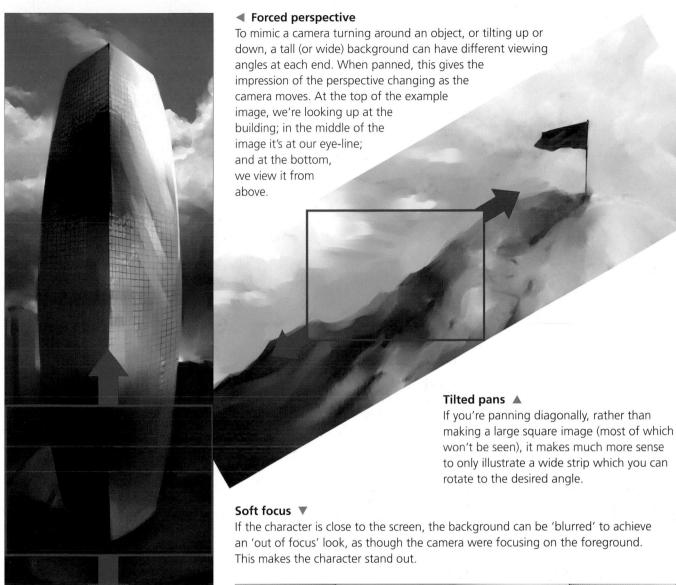

Tip: You will soon find that many of the best animation tricks you learn are those that save you time in some manner, often while 'violating' a rule - of perspective, of finished art – that you held in high regard earlier in the book. Because drawing takes so long compared with doing a single image, 'perfection' should be found in an enjoyable finished result, but not in a single frame. There's no point in drawing (or animating) every single blade of grass in a field if the grass will be on screen for less than 20 seconds - the viewer's eye won't appreciate the detail. Apply detail only where it is needed: everywhere else, it is worth cheating.

If the character is close to the screen, the background can be 'blurred' to achieve an 'out of focus' look, as though the camera were focusing on the foreground.

Animation

Creating a fully animated character can certainly appear daunting at first. The scenes should be taken one at a time and can be split into a few simple steps. Even working digitally, the most effective method for character animation mimics traditional hand-drawn frames, a process which can be divided into three main steps: rough key-frames, in-betweens and

cleaning-up. Once your character animation is done, you can compile the scene atop your great background, add your sound effects and move on to the next. Remember that you don't need to work on the animation in chronological order — it's best to tackle the simplest scenes first. It can also help to have a group of similarly minded friends to help you.

Rough key-frames

Once you've chosen a scene to animate, you should think about how the character moves and divide the movement into key poses.

Your key poses should show the start (and end) of each action or motion. For example, a character jumping could be divided into: standing pose; knees bent; apex of jump; knees bent; and back to standing. No matter what software you use, a graphics tablet will make drawing your frames much easier than using a mouse or trackball. These key-frame drawings aren't meant to be final artwork, and should only be sketched out at this stage.

Once you've drawn your rough keys, you can adjust the timing. A two-second jump at 12 frames per second should have the key-frames span 24 frames (2x12=24). Although this sounds

like a lot of frames for a short amount of animation, remember that many frames will be identical and you can hold the first and final pose to add a few seconds to the animation. Now you need to think about in-betweening.

Beginning and ending frames ▼ In this example, our character begins shocked by something, and ends by pulling out a rocket launcher and declaring war. The movements are all in the arms and face.

In-betweening (tweening)

The process of drawing the frames between your rough key-frames to create smooth transitions is called inbetweening or tweening. At animation studios it's common for in-betweens to be drawn by assistant animators, but assuming you can't afford that luxury, let's get to work. Drawing a frame between two others can be tricky at first, but turning on 'onion skinning' will show faint versions of the previous and next frames, emulating a lightbox. To create your first in-between, simply redraw the character's body parts halfway between the two surrounding frames. Repeat the process to add more frames between. In-betweening can take some practice to get right, but there are a few tricks to creating smoother in-betweening.

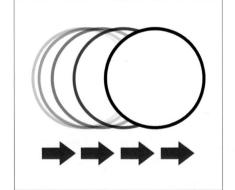

Ease in 🔺

Equal distances between each frame can make animations look robotic.

To 'ease in' to a movement, the first in-betweens should be closer together, the distance increasing with each frame, making the action accelerate.

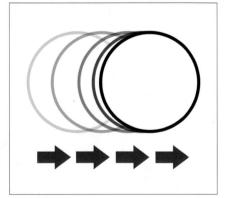

Ease out A

'Easing out' from an action makes a movement slow down to a stop. The end of the 'tween' should become tighter with the distance gradually decreasing between each frame until the movement reaches a standstill.

Overstretch A

Fast-moving limbs coming to an abrupt stop (punching the air, for example) look unnatural. For smoother-looking animations, add an extra frame before coming to rest which continues the momentum farther than the final frame.

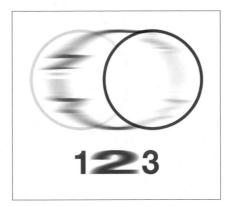

Motion blur A

One frame might have to convey movement over a relatively large distance with a fast-moving object. Stretch or blur it across the full distance to make the animation smoother. Experiment with blur effects.

Tip: Before moving on to cleaning up your frames, be sure to play and analyse the animation several times, tweaking and adjusting individual frames as necessary. This is often called a 'line test', as you view the animation in its raw, line art state. Most modern software will provide you with ways of adjusting your inbetweens in much easier ways than by doing it manually on paper, giving you the ability to select and move small areas of each frame. Test and test again - it is important to get the motion of your characters perfect when it is in this state, as it's much harder - not to mention hairpullingly time-consuming – to fix any problems in the animation when the frames are inked and coloured.

Cleaning up

Once you're happy with how the rough animation flows, you can start turning your rough frames into final artwork. There are many methods for doing this, but with traditional anime the roughs would be traced on to cels (transparent

celluloid sheets). To reproduce this method digitally you can create a new 'layer' above your digital pencil test where you can trace your neat artwork. Alternatively, you can work directly on the sketches to clean them up.

Once clean versions of your rough frames are prepared, you can begin to colour the frames. Once all the pieces are ready, you can put everything together, add sound effects if needed, and finish the scene.

Colouring ▲ ►

There are many styles of colouring to choose from, but the easiest is to use solid colours with no shading. The majority of

anime, however, uses the distinctive visual characteristic of shading at a high contrast from the flat colours. To reproduce this look, you should outline and in-between the shapes of the shadows before filling them with colour.

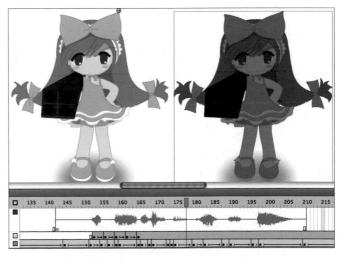

Filling with colours

Choosing which colours to use can be difficult. The characters have to stand out from the background, but not look out of place. Consider the lighting of the background. Night scenes might be rendered in shades of blue, summer scenes in bright saturated colours. In Flash you can adjust colours of an object with the colour settings of the properties panel, even changing the colours of characters within a scene: so your characters can meet and interact as the sun is going down, or in a darkened warehouse where fluorescent lights are suddenly turned on.

Cute dancer project

A cute dancing animation is an ideal first project, as the animation required is relatively simple; and the same frames can easily be repurposed to any kind of soundtrack you desire, whether by changing the timing using key-frames to sync up the dancing with the music, or by quickly recolouring your dancer and swapping in a new background to better suit a different genre. Such addictive and amusing animations often of no more than 15 individual frames, repeating to crazy, sped-up music - can be found all over the Internet, spliced together by budding animators eager to make their mark on a worldwide craze. While you could seek out one of these animations and directly copy the poses as practice, for this project you will be creating your own completely original dance moves. The instructions for this project apply to Adobe Flash, but if you are using another animation package, the steps and process will likely be very similar.

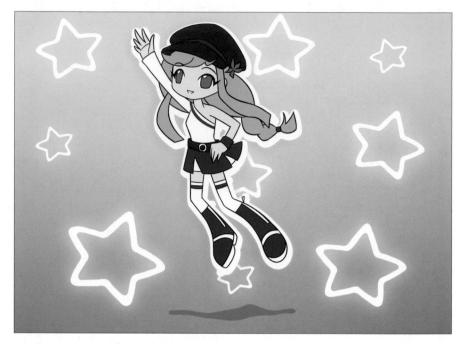

Dance dance animation revolution A

The animation uses a vibrant, abstract background, and couples it with an extremely simple flat colour scheme for the central character. Only a few frames are needed to capture the dancing movement effectively.

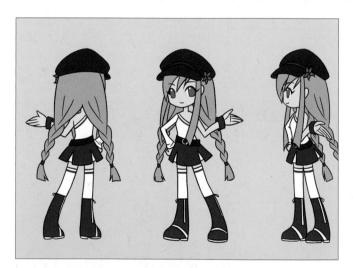

The first step in your animation is to create your dancer. You will need to start with a model sheet turnaround of your character. The key here is simplicity: simple anatomy, engagingly cute form, minimalist colours and relatively few extraneous details. Our example, show above, is 'Eclair', a design that takes elements of a cheerleader and knocks them ever so slightly off kilter. The character herself is almost Chibi in proportion, with simplified hands and feet, and a face that is mostly large, shiny eyes. She contains only six colours. She also boasts long flowing hair and a segmented skirt that will react to her jumping around with interesting secondary movements.

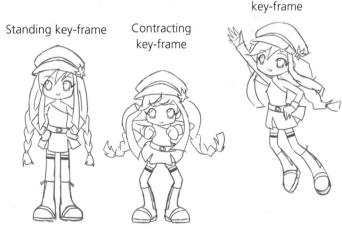

Apex of jump

As mentioned in the project outline, your dance will not need many frames to be effective, with only three key-frames being unique. The rough keys you will have to draw will therefore be the initial, neutral standing pose, followed by a second pose featuring the character contracting, ready to jump, and the third and final key-frame, the apex (highest point) of her jump. In our example animation, Eclair will jump to the side, rather than straight up, as this means that you can effectively double the length of your animation by having the character jump to each side in turn. The second jump can be, more or less a repeat of the first only with the jumping frames flipped.

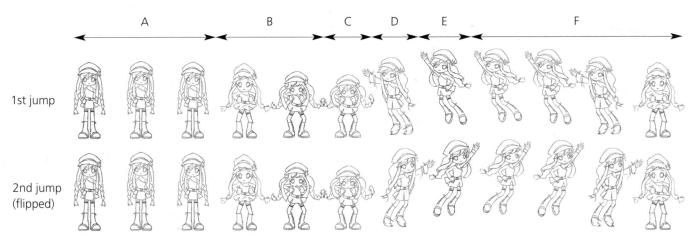

3 With your key-frames complete, it's time to move to inbetweening. As the second jump reuses frames from the first, you only have to in-between one. You can then modify it, rather than having to in-between both jumps. The stages below correspond to the timeline above.

A Before contracting, move the character in the opposite direction to her jump, extending her body as she 'inhales'. This keeps the animation 'bouncy' and makes the crouching frame more pronounced. This frame is a modified version of the first, head higher up, body slightly stretched. Her hair swings inwards. You can select portions of the sketch with the Lasso Tool, Transforming them to make slight changes.

B After returning to her original position, drop the character to her ducked-down position. The in-between is a halfway frame between standing and crouching. As she's moving very fast, stretch her to produce a motion blur effect. Leave her hat higher up to show it falling more slowly.

C After the crouching frame, ease out the movement of the previous two frames. Duplicate the crouching key-frame, moving her head farther down, her legs closer together and continuing her hair's momentum.

D Moving between the contracted pose and the jump should be very quick: it's in-betweened in a single frame. The jump key-frame is used as a base, but redraw and blur her limbs and stretch her hair and skirt.

E A modified jump frame follows the key-frame as the actual apex of the jump, easing out the motion as gravity catches up with the character. Bend her legs slightly, make her hair bounce and continue the momentum of her hand.

F On the character's descent, the frames making up the ascent are reused in reverse order. Modify the blurred frame slightly so that the hair falls slower. Before returning to the default pose, the blurred crouching pose is reused to show the character quickly dipping on impact.

Play the animation and analyse it, tweaking any frames that need adjustments. The frames are then all repeated, with the second jump's frames flipped. Of course, as the design is asymmetrical, some of the details, particularly in the top, will need editing after the frames are flipped.

5 When you are content with your animation, clean up the frames. Copy the frames into a new graphic symbol called 'Eclair' and add a new layer. Trace unique frames with either the Pen Tool or Brush Tool. Alternatively, prepare your frames in another program and import them into Flash. Don't draw identical frames more than once.

Once all the frames are finished in the top layer, you can remove your roughs, exit the graphic object, and place it into context on the stage. You can then add a simple background in a new layer below the object. Make sure the 'Eclair' graphic symbol is set to Loop mode, then insert enough frames (on both layers) to cover whatever music you want her to dance to.

Walk-cycle project

The somewhat daunting 'walk-cycle' is essential to the animation of human or bipedal characters. Its complex nature makes it great practice for all the fundamentals of animation. The resulting frames can be reused in a variety of ways and circumstances in your animations. It is slightly more advanced than the previous project, but breaking it down into small steps simplifies the process. Like many artistic endeavours, it is more time-consuming than difficult. Unlike our last project, a walk-cycle will almost certainly be a part of a larger project. If you're planning a project that could use a walk-cycle, this is a great place to test and hone your abilities.

Walk-cycling the mean streets ▶

Using a scrolling, repeating background, a similarly repeating walk-cycle and a number of foreground elements that pass in front of the character, you can create a very convincing – and reusable – animation of a character out for a walk.

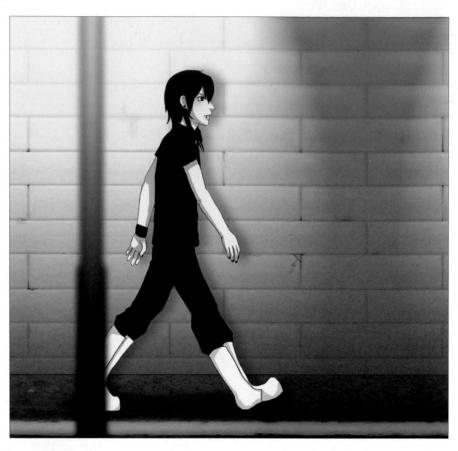

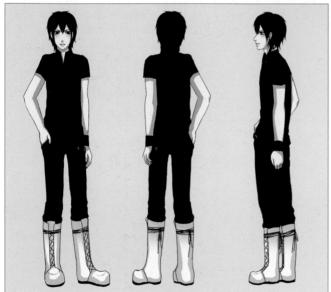

1 Before beginning your animation, you will need to create a model sheet for your walker. Here, we have created a more complex character in a mature style, making use of six base colours and their attendant shades. Anime-style celshading significantly increases the amount of colours in use on every frame, but this character's relatively simple clothing keeps the colouring process from becoming too complex.

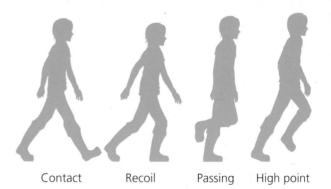

When you are satisfied with your character, start creating your rough key-frames. A walk-cycle typically has four key-frames per stride: 'contact', 'recoil', 'passing' and the 'high point', making eight key-frames for a full cycle (four for each leg). The animation starts with the most important 'contact' pose, where the foot touches the floor. In this frame, the legs and arms are at their farthest apart. The second key-frame is the 'recoil' pose, where the character's weight is transferred on to the grounded foot. This is followed by the 'passing' pose where the character's legs and arms pass each other. The character then pushes himself into the 'high point' pose, bringing his opposite foot forward ready to land into a second 'contact' pose.

Rough in key-frames for both strides, as shown at right. How far the character contracts and expands during the recoil and high point can change the look of the walk. Posture and the swing of arms and legs can also help represent their personality.

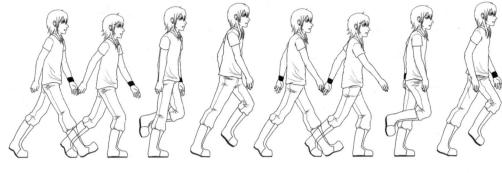

As the walk-cycle has a relatively high number of key-frames, you can playtest and adjust your keys before adding in-betweens, making sure the animation plays nicely. Because this character is rendered with cel-style shading, it can be useful to outline shadows at the key-frame stage.

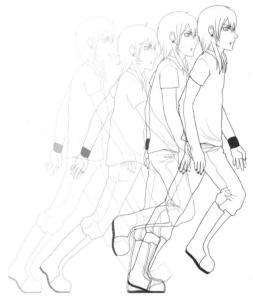

5 Once the key-frames have been tested and tweaked, add in-betweens. For animation at 12 frames per second, a single in-between for each key will be sufficient for a stroll (totalling 16 frames). The walk-cycle is one continuous motion, so each in-between should be halfway between the surrounding frames, with no easing in or out.

Clean up your frames after tweening. Copy them into a new graphic symbol and add a new layer. Trace each frame with the Pen Tool or Brush Tool. Once the frames are inked and coloured, add shading by selecting each fill and drawing in the shadow. You may need to move your rough layer to the top. You can then delete your roughs, exit the object, and place it on the stage. Set it to loop mode.

Create a seamless background (the left edge must match perfectly with the right) in Photoshop and then import it into Flash, so that the character can walk across the screen, or have the camera tracking the character with the background scrolling past.

To animate your background, make a graphic symbol called 'looping bg' with two copies of the background. Convert the backgrounds to their own symbols and layers and 'motion tween' (or 'classic tween') them, so that the second ends up in the place of the first. Adjust the number of frames so the tween moves at the right speed. 'Create Key-frame' on the penultimate frame, then delete the final frame. This removes the duplicate of the first frame.

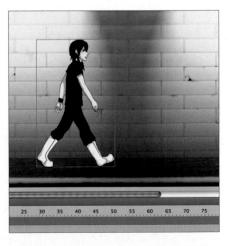

9 You now have a symbol containing a looping background which you can drop into the stage on a layer beneath your looping character.

Index

Adobe Flash 84 Adobe Illustrator 70 Adobe Photoshop see Photoshop Akira 82, 83 animation 90–1 anime 80–95 AnimeStudio 85

backgrounds 36–7 anime 88–9

cel shading 44, 47, 48–9, 62, 75, 79 close-up view 87 colouring, digital 42–55, 58–9, 67 Corel Painter 6, 7, 70, 84 cute dancer project 92–3

digital methods see Photoshop dreamy reflection 64

EasyToon 85 eyebrows 35 eyes 11, 14

fight scene project 40–1 Flash animation 84 focus lines 29 graphics tablet 7

hardware 6–7 history, anime 82–3

inking, digital 22–3, 36–7 interiors 36–7

kodomo, digital project 76-7

lettering digital 30–1 SFX 32–3, 40–1 lighting, digital 68–9

metal armour 62–3 Miyazaki, Hayao 83 motion 60–1

natural setting 37 night image project 54–5

Otomo, Katsuhiro 82

perspective 89 Photoshop 6, 7, 8-19 anime 85 Blur and Sharpen 16 Clone Stamp Tool 16 colouring 42-55, 58-9, 67 combining software 70-1 converting a photo 66-7 customizing colour palettes 58-9 Dodge, Burn and Sponge 17 filters 34-5 focus lines 29 inking 22-3, 36-7 layers 18-19 lettering 30-3, 40-1 lighting 68-9 metallic look 62-3 motion in colour 60-1 paint tools 12-15 reflections 64-5 scanning and retouching 20-1 select and transform 11 Smudge Tool 17

speedlines 28–9 toning techniques 24–7 view and selection tools 10 point-of-view (POV) 87 Pokémon 82 Princess Mononoke 83 printer 7

robots 76-7

scanner 7
seinen, digital project 78–9
shojo, digital project 72–3
shonen 78
digital project 74–5
skeletal structure 85
soft shading 47, 50–1, 64, 73
sound effects 75
speech balloons, digital 30, 31
speedlines 28–9
Spirited Away 83
storyboarding 87

Tezuka, Osamu 82 tilt 89 tone 24–7, 67 Toon Boom 84

walk-cycle project 94-5

Acknowledgments

The publisher would like to thank the following for kindly supplying photos for this book: ALAMY: Alamy Photos (12) 83 (bottom left and right); CORBIS: Annebicque Bernard/ Corbis Sygma, TWPhoto/Corbis 82 (top); GETTY IMAGES: Getty Images/APF 82 (bottom right), 83; TOPFOTO: Topham Picturepoint 82 (bottom left).